Trompe L'Oeil

Italy
Ancient
and Modern

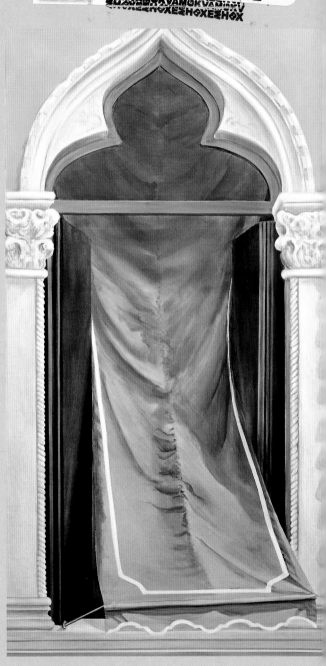

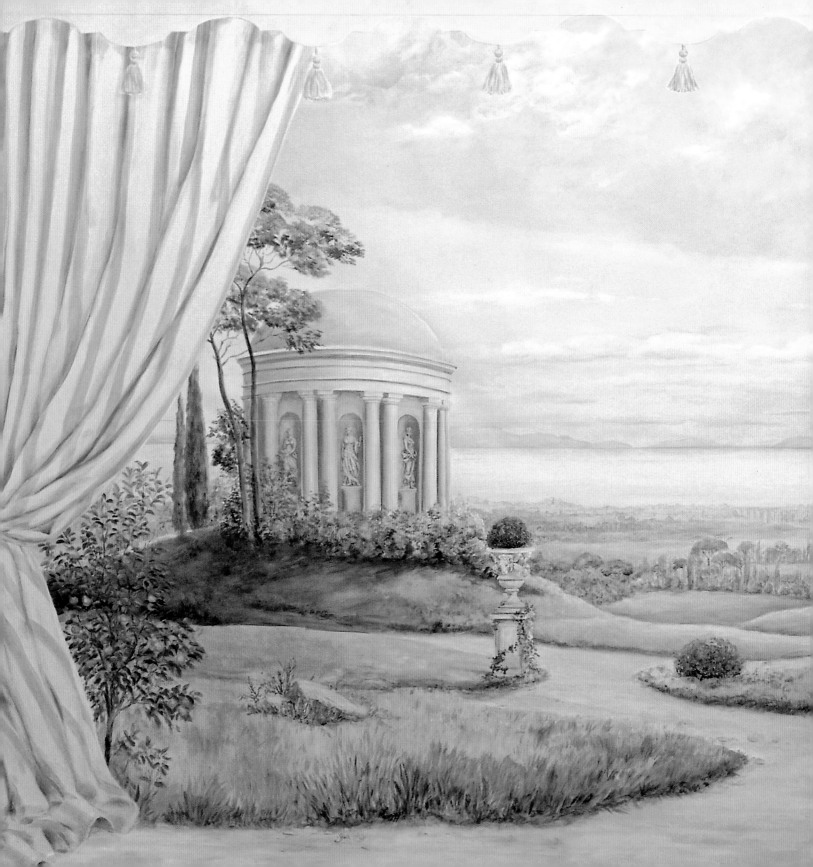

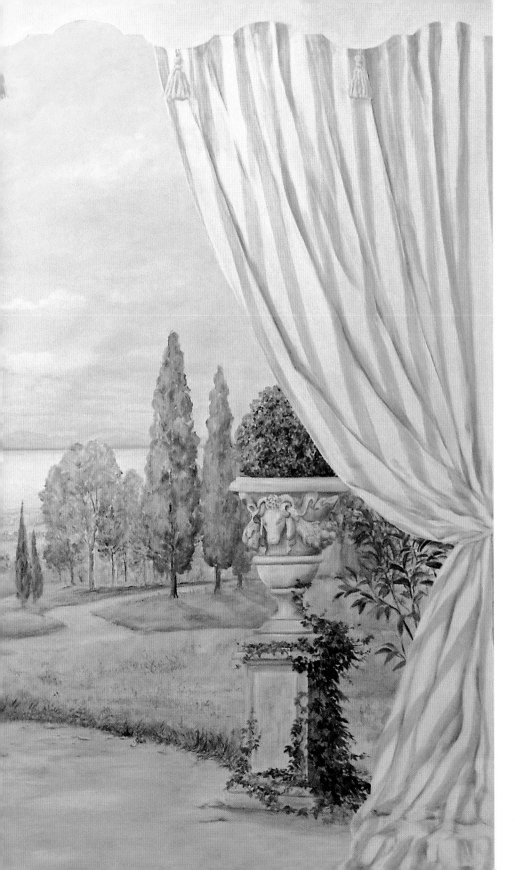

Ursula E. and Martin Benad

Translated by Anna Steegmann

Trompe L'Oeil

Italy
Ancient
and Modern

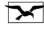

W. W. Norton & Company

New York • London

Translations of Goethe by Anna Steegmann except excerpt page 8, from "Wilhelm Meister's Apprenticeship," Vol. XIV, Harvard Classics, Shelf of Fiction, New York: P.F. Collier & Son, 1917; Bartleby.com, 2000. www.bartleby.com/314/. 8/31/2007.

Copyright (c) 2007 Deutsche Verlags-Anstalt, Verlagsgruppe Random House GmbH
English translation copyright (c) 2008 by W. W. Norton & Company, Inc.

Originally published in German as ITALIEN: ANTIK UND MODERN:
Studienreihe Illusionsmalerei

For information about permission to reproduce selections from this book, write to Permissions, W. W. Norton & Company, Inc., 500 Fifth Avenue, New York, NY 10110

For information about special discounts for bulk purchases, please contact W. W. Norton Special Sales at specialsales@wwnorton.com or 800-233-4830

Manufacturing by KHL Printing
Book production by Joe Lops
Production manager: Leeann Graham

Library of Congress Cataloging-in-Publication Data

Benad, Ursula.
[Italien antik und modern. English]
Trompe l'oeil Italy : ancient and modern / Ursula E. and Martin Benad ;
translated by Anna Steegmann.
p. cm.
ISBN 978-0-393-73241-2 (pbk.)
1. Decoration and ornament—Trompe l'oeil. 2. Decoration and
ornament—Italian influences. I. Benad, Martin. II. Title.
NK1590.T76B4713 2008
745.40945—dc22

 2007037135

W. W. Norton & Company, Inc.
500 Fifth Avenue, New York, N.Y. 10110
www.wwnorton.com

W. W. Norton & Company Ltd.
Castle House, 75/76 Wells Street, London W1T 3QT

0 9 8 7 6 5 4 3 2 1

Contents

Italy
Ancient and Modern

Why Italy?

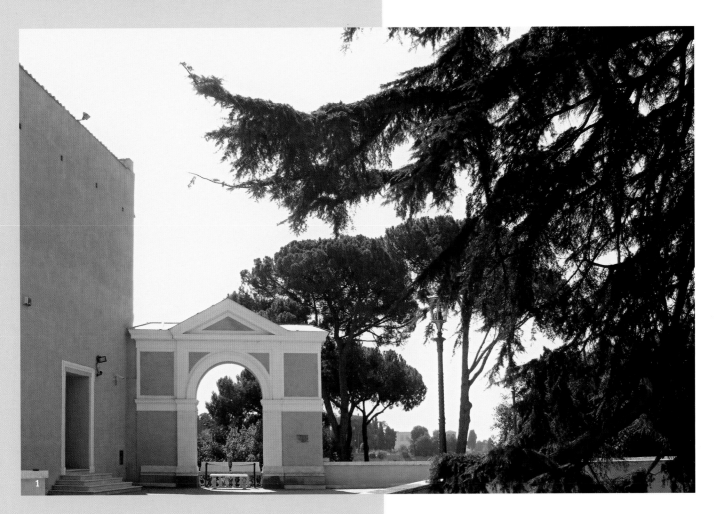

Italy is an essential if not the most important sub-
ject of trompe l'oeil painting. Anyone pursuing
Italy's cultural history, its nature and way of life,
will find a wealth of inspiration. Trompe l'oeil
painters in particular should be required to study
Italian motifs.

Focal point
of European cultural history

1, page 5
Terrace with view of the Capitol,
with Lebanon cedar and picturesque archway

Italy is of major importance in Europe's cultural history. Its development over the millennia is reflected in its monuments dating back to Etruscan times and ancient Greece. From the end of the Middle Ages, cities like Florence, Venice, Siena, Naples, and Rome have been leading centers of European art. In the fifteenth century, Florentine artists and scholars brought us the Renaissance. Since then many important European artists have traveled to Italy for education and inspiration. If we study architecture, sculpture, poetry, music, theater, opera, and (mural) painting today, we have to refer to Italy. Although an examination of Italy's cultural history is an important matter, this is not the place to do it. Nevertheless, Italy's immense cultural heritage is always present in the background whenever we transfer Italian motifs to painting.

2

The emblem of the Eternal City: the Capitol's she-wolf

Land of longing

Italy has always been the country of longing, the country of dreams. Trompe l'oeil paintings often express these longings and dreams. An Italian Mediterranean ambiance lends itself to shape and direct the vague shapeless yearnings of its viewer. Tuscany's picturesque cottages, its cypress-lined roads and olive groves; Venice with its fairy-tale palaces, canals, and gondoliers; the Amalfi coast; the temple ruins of the Lago Maggiore—Italy is always more beautiful, enchanting, romantic, and more ideal than other places. At times, Latin writers have moved Arcadia in the central Peloponnesus, glorified as belonging to the "Golden Age," to Sicily because the ideal landscape, the happy shepherds untroubled and in harmony with nature and themselves, could have lived just as well in Italy as in Greece.

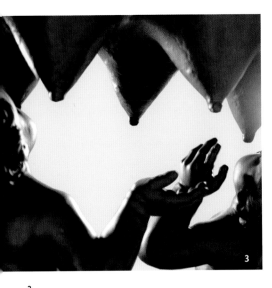

3
Like Romulus and Remus, nurtured by the she-wolf's milk, artists have found inspiration and nurturance in Italy's cultural history.

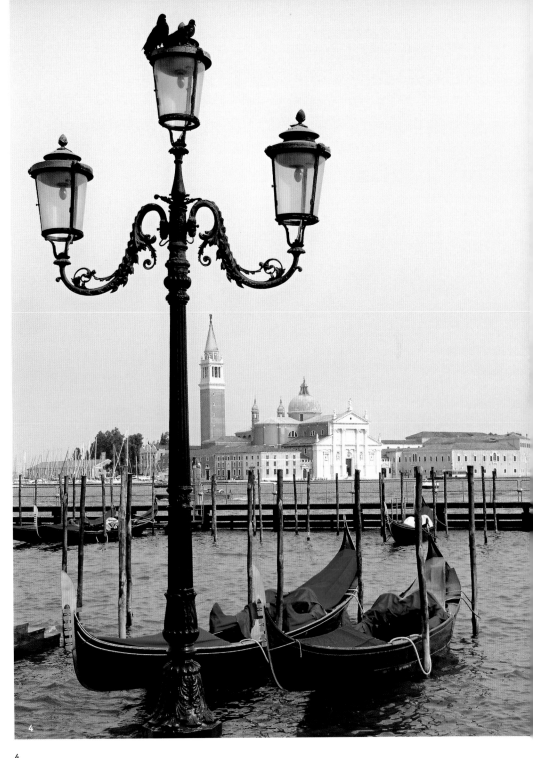

4
Palladio's San Giorgio Maggiore with Venice's typical gondolas and lanterns: a theme often replicated in mural painting.

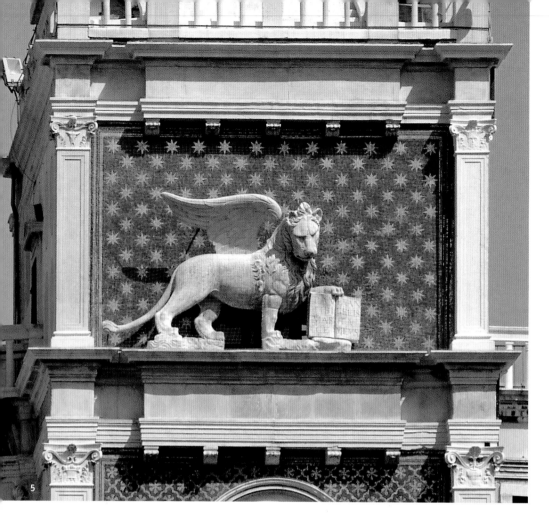

Italy: beloved around the world

Since the mid-eighteenth century, wealthy Europeans and among them mostly English nobility, have been drawn to the legendary land of vast art treasures and famous ruins. The archeological excavation sites in Pompeii and Herculaneum were tourist attractions from the beginning. The ancient murals and cultural artifacts influenced the style of European classicism. To furnish one's home à la Herculaneum was once a new design craze.

Today, many people think of Italy as a place where nature and culture converge. In Italy we can take a vacation on the beach or we can go

In 1792, Goethe, looking back, wrote: *"The goal of my innermost yearning, the pain it caused to my entire being, was Italy. I envisioned its likeness and parable in vain for many years until I made a bold decision and dared to seize its real presence."* (Campaign in France, 1792, in Artemis Gedenkausgabe der Werke, Zürich, Stuttgart, 1948ff., page 367)

In "Wilhelm Meister's Theatrical Mission" Mignon's song expresses words full of longing:
*Know'st thou the land where lemon-trees do
 bloom,
And oranges like gold in leafy gloom;
A gentle wind from deep blue heaven blows,
The myrtle thick, and high the laurel grows?
Know'st thou it, then?
'Tis there! 'tis there,
O my belov'd one, I with thee would go!*

5
Venice greets us with its heraldic animal, the winged lion.

6
Not only the landscape is enticing—all of Italy is an open-air museum of monuments. The Pantheon has stood in the center of Rome for 2,000 years . . .

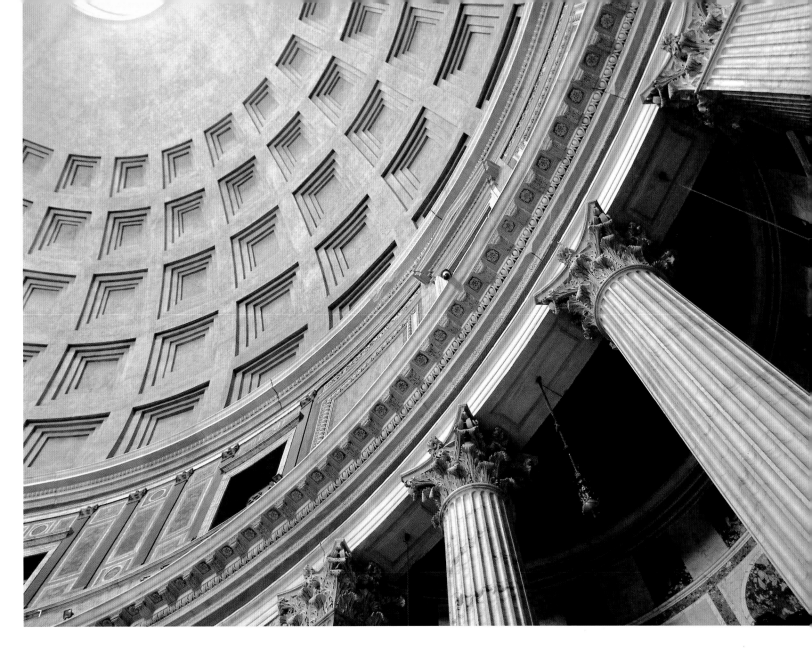

on an educational excursion into the center of Western art history. We can hike and ski, visit the opera or the Vatican, eat and drink remarkably well, and enjoy life to the fullest. We can shop in Milan, spend our honeymoon in Venice, or rent a Tuscan cottage to forget our troubles and enjoy sweet idleness.

The air is sweeter, purer, the sky bluer and less cloudy; the faces are open, friendly, and smiling; the bodies are more regular and more entic- *ing. Even the green of the meadows and trees are not as cold and dead, but higher, brighter, and richer than in the north. Pleasure invites us; nature and art walk hand in hand.* (Goethe, J. D. Falk, 7.17. 1792)

7
. . . with a gigantic cupola resting on powerful marble columns.

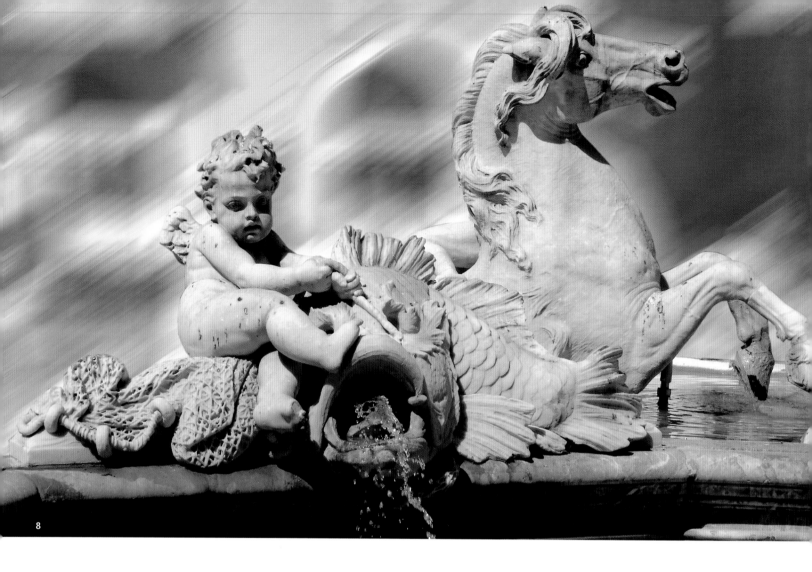

The boundary between legend and reality surely is different today than in the eighteenth century. The pure air Goethe described is not the same air we breathe in Rome today. When we spend time in the historic city centers that attract millions of visitors, we may ask why the art of the built environment has become mostly a thing of the past.

Tuscany's eroding slopes and the eroding morals of today's politicians do not embody Goethe's lines. But the discrepancy between past and present becomes minimal when we stand in front of the overwhelming evidence of the past, when we feel enchanted by Italy's countryside or end our day on a lively piazza. Life becomes a dream.

The border between the modern, often sobering present and the grand idealized past disappears. We cherish the beautiful memories of our journey to Italy. The right trompe l'oeil painting can keep these memories alive.

8
In Italy trompe l'oeil painters find motifs for their murals everywhere. This one is from the Fontana del Nettuno in Rome's Piazza Navona. The soft-focused background allows us to see the sculpture better.

9
The heavy drapes of a café in Piazza San Marco, Venice, are first-rate painting templates. Never go out without a camera or sketchbook when you are in Italy.

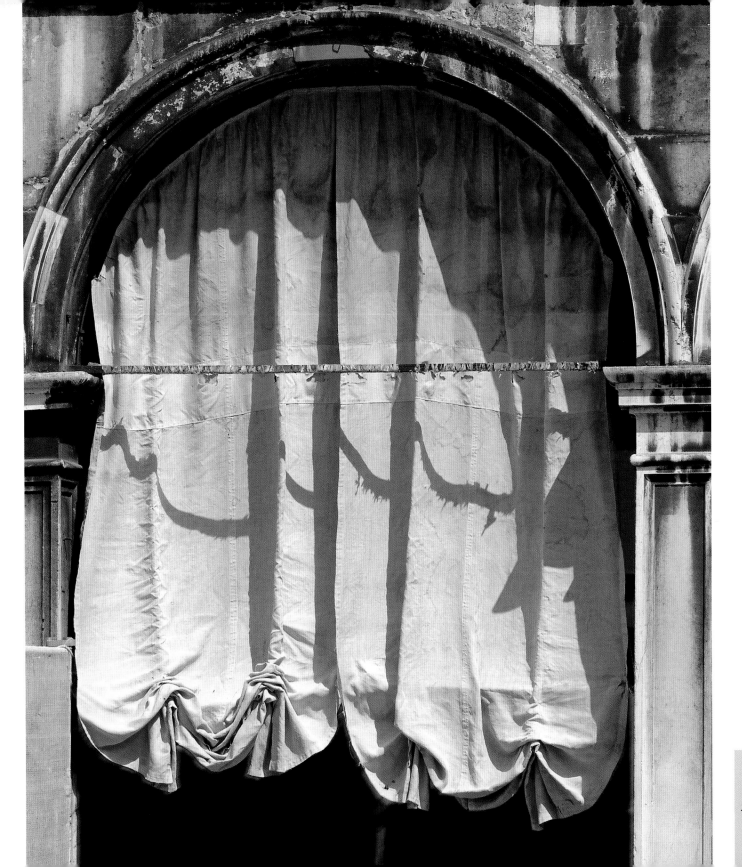

10

11

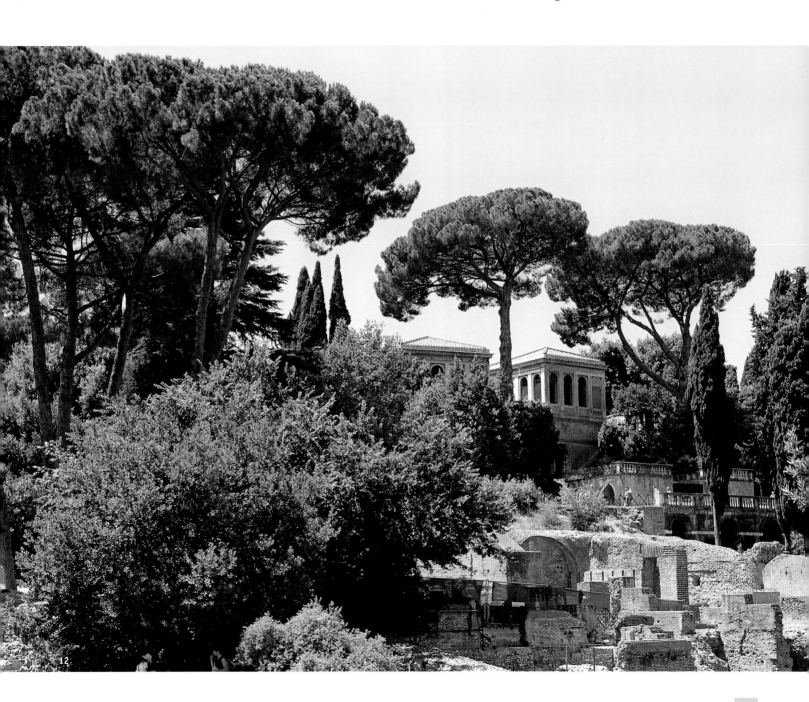

12

A way of life

Italy is more than a country. It's a way of life, a love of life. Italy is sensual and social. We enjoy life as a group, in a family, or in a circle of friends so much more than alone. The wine and food are superb, the clothes sensual, and the cars racy. Art infuses all of life. More than a hundred thousand significant monuments turn the entire country into an open-air museum. The marble we find in other parts of the world in mansions is used here for sidewalks. Life happens outside, in the open air, the warm sunshine, on market squares, in the streets, next to churches and wells built centuries ago. The Italians don't necessarily need to meet in the Campo of Siena, Venice's Piazza San Marco, or in front of the Pantheon (this two-thousand-year-old fossil and wonderful oasis in the heart of Rome). Every village has its own public square. People are more social and talkative here than elsewhere. To foreigners, these lively squares evoke memories of days gone by. A self-confident, modern, stylish Italy enjoys itself in the monumental backdrop setting of a luscious, majestic past. Who would not want to be part of it? Via painting we can—at least partly—export this way of life. Rooms meant to provide relaxation and well being, like spas and wellness centers, restaurants, dining rooms, and winter gardens, are predestined for Italian motifs. We might call such refuges of the Italian way of life "stress-free zones."

13
Gondola ride through the canals of Venice

14
Italian ambiance: pleasurable wining and dining with a grand setting and live music (Piazza San Marco, Venice)

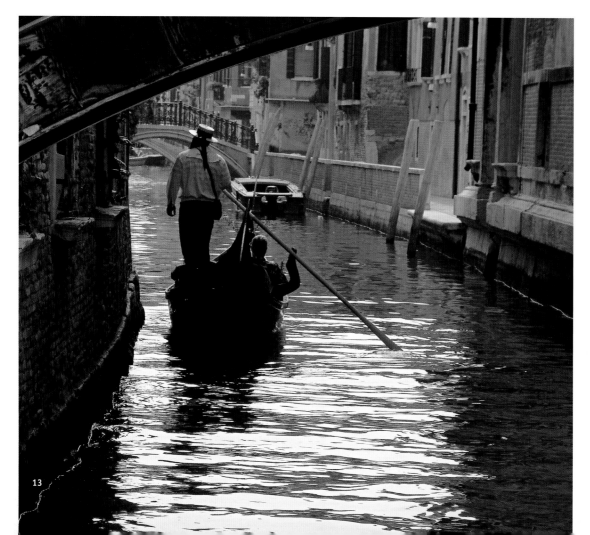

13

Boundless variety

The great masters

Italy stretches from the snowy mountain tops of the Alps to sun-drenched Sicily. The Italian shores stretch thousands of miles. We find big cities and villages, industry and agriculture, thousand-year-old art next to modern design. There's little we won't find in Italy: it is a microcosm. The visual motifs we can transform into murals are so manifold that it is hard to imagine that they all originated in one country.

The modern trompe l'oeil painter will want to refer to the great masters of fresco painting. Impressive visual language illuminates Italian churches and palaces. Modern history began with Giotto's frescos; then came the Renaissance and mannerist murals (i.e., Michelangelo's Sistine Chapel, Raphael's "School of Athens," both in the Vatican, and Veronese's "Feast in the House of Levi," in the Accademia, Venice) and Tiepolo's grand baroque paintings. If so inclined, we might want to copy the "Creation of Adam" or Raphael's cherubs with their bows and arrows from the Villa Farnesina. We might want to allude to Veronese's girls peeking at us from behind the door, or Caravaggio's fruit basket. We can argue about the merits of a fast copy done with acrylic paints sold as a "fresco painting." No doubt, everyone who designs and executes a mural can learn a lot about composition, color choice, and painting technique from Italian fresco painting of the fifteenth to eighteenth centuries.

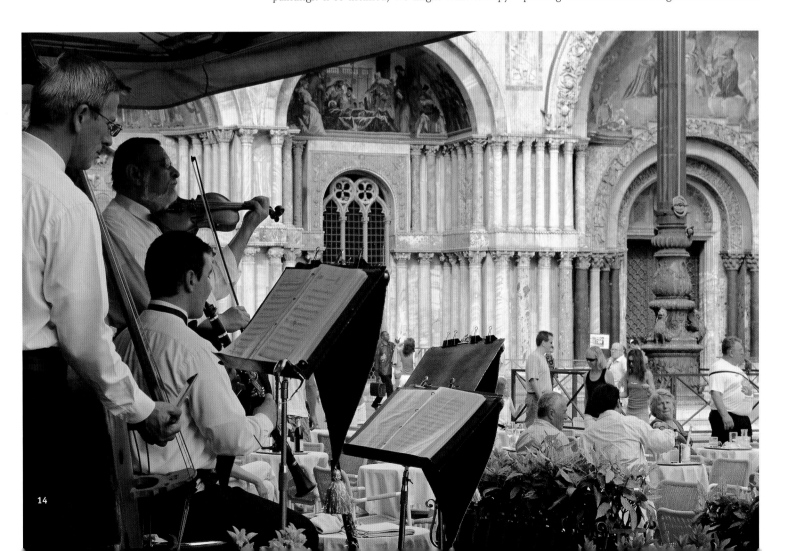

Ancient and modern

Traveling to Italy, we discover our own Italy. We discover a new life and the desire to confront the great monuments of the past with our present life. The marble mountains of St. Peter's Basilica, the "bloody" stone sculpture called the Coliseum, a mosaic from Pompeii done by an artisan two thousand years ago, the abundance of temple ruins in a divine landscape—all are hard to comprehend. We wonder, is this possible? Can I paint like this? Some of us begin to doubt. How insignificant and trivial my painting is, how profound is history.

What is "ancient"? A period of antiquity, the art treasures of the Roman Empire?

What is modern? Modern art from the beginning of the twentieth century? Intellectual modernity, the Age of Enlightenment when all independent thinkers became modern?

We can use "ancient" as a synonym for old as opposed to "modern," new. Modern would mean contemporary, the newest Ferrari or Alfa Romeo, the latest movie, the Gucci collection of the season, or the Alessi teapot in a slick magazine ad. The Roman Empire would be just as "ancient" as a Vespa built in 1950 or last season's ball gown. In our context, we understand "ancient" and "modern" as a mix of these interpretations. Readers of this book are modern. We live in the third millennium as we approach an old cultural heritage. The origins of this heritage date back to antiquity, the time before 600 CE; "ancient" stands for origins, not a specific date. Even the Renaissance and the classical period contain antiquity. Today's readers not only wear the latest fashion and portray trendy objects in our paintings; we are concerned with modern content. We work with this content (especially the really old) to meet Goethe's demand: "That which you inherit from your father, you must earn in order to possess." (Faust, Act 1) Modern is not an absolute, limited time frame, but an inner attitude.

15, 16
Past and present converge

All of us who face the cultural treasures of the past—not only antiquity—experience the hidden behind the notion "ancient and modern." In our hunger for knowledge we visit a museum, unwind with a glass of wine on an "ancient" square, feel smitten by an old wall or an old statue. Standing on the Piazzale Michelangelo we might use our digital camera to capture the view of Florence. We might start to travel back in time while sitting at the bottom of a temple in Paestum. An artist can't check off these impressions like a tourist. We are immediately affected by what we see. Our past is part of the past we encounters. How do we absorb it? How do we present it to our clients? How do we build a bridge between our clients' present life circumstances and the figures to be shown in a trompe l'oeil painting?

Ancient subjects and modern elements

In trompe l'oeil paintings objects and landscapes are presented so that they—with some good will—might be taken for real. The painted figures have to be woven into the room; they need to be placed so that their representation inside the home is credible. Here "modern" refers to the picture's elements that do not originate in the time of the represented object, but in the present home of the painting. A golf club, sunglasses, a handbag, car keys, or a pet—the list of personal objects is infinite. But we have to be careful. The "immortal" subject should not be decorated with modern accessories meant to amuse. Unlike the main object, the viewer will grow tired of it soon. Modern elements can be architectural components of our time that may

frame or extend the painting: the painted view of timeless, idealized Tuscany does not have to be surrounded by draperies or marble columns. Venetian blinds and a piece of string might work just as well, especially when shapes and colors match the room's arrangement.

Kitsch and creativity

Each painting expresses a personal relationship between the painter and his or her subject. Trompe l'oeil painting often uses subjects that have become clichés. Some templates have been copied a million times: the famous fragment of Michelangelo's "Creation of Adam," the singing gondoliers, the Leaning Tower of Pisa We might want to agree with Goethe (to Zelter, 5. 29. 1817): "This Italy is trite, if I didn't see myself in

17

The frame shows the viewer looking at a picture. A transition is created between the onlooker's world and the world portrayed. Being aware of it becomes part of looking.

Classic trompe l'oeil painting shapes this transition so we hardly recognize it. The painted frame is borrowed from real space as an architectural element or a drapery. Modern trompe l'oeil painting can give us this frame so the viewer becomes more aware of the painting's subject matter.

The fascination of painting

Trompe l'oeil painting is about the presentation of the image, the way it is presented. In successful works the presentation is more important than the presented object itself. Painting is not photo wallpaper or a digital print, but the result of a soulful act. Only that way can painting create a mood; only that way will the viewer continue to look at the painting. A glazed landscape painting allows us to see how the painting was created. The traces of this process remain visible; the image is formed anew in the viewer; the process never ends completely. Nevertheless, representational trompe l'oeil paintings should appear "finished."

A modern way of looking can be advantageous, so long as the process of creating the painting does not aim at a photorealistic representation of nature. The represented motif should still carry the vigorous, unformed painting process in it.

a juvenile mirror, I would not want to know anything about it." Needless to say, Italy is not trite; the reproduction of Italian figures is. Everyone knows these figures and because we all "know" them already when we see them anew, these motifs hardly stand a chance to convey any meaning at all. We need to be creative and we need to disappoint traditional expectations of trompe l'oeil painting. We can no longer paint the Rialto bridge; we can only refer to paintings of it. You will not find the Rialto bridge in this book. We ought not to portray the gondolier singing, but with an oar in one hand, a cell phone in the other.

The frame

Some artists can not live without photocopy machines, digital cameras, and projectors. These tools demand that artists interact more intensely with what they see and how they see it. Who else but the artist can understand the world? Tourists explore their environment with their digital cameras, not with their senses. From photo books and Google's worldwide picture archive a multitude of pictures not truly seen, not truly felt, position themselves between us and our world. It's not about seeing pictures like an ancient temple, a Venetian palace, or a Tuscan cottage. It's about understanding their spirit. Either three million or eight million pixels will not bring us closer to the truth. A picture's mystery is not revealed by its resolution. In this context "modern" stands for an approach to pictures that enables us to read them and to discover new and unique features in them. We can fit the Coliseum, Pisa's Tower, Venice's Doge's Palace, and many other monuments into a modern framework. An old image is alluded to as a backdrop setting, but the allusion has a unique substance we can refer to.

San Giorgio Maggiore: the "ancient" becomes the backdrop of the "modern," an allusion to a world that many of us long for.

The sense of style

Trompe l'oeil paintings done in fresco style are exceptions. They do not create the illusion of a landscape or an architecture we can take for real: special illusionistic elements are blended with decorative two-dimensional elements. Looking at Pompeian garden paintings we do not feel transported to a garden but to the world of plants and animals. Done stylistically convincingly, we experience some sort of garden.

Illusionism that plays with painting in the style of ancient frescos is neither a perfect deception nor a perfect copy of the old masters. The viewer should experience the walls as ancient, weathered, and painted "in ancient fresco style." Material sub-ject and historical context are simulated. This is a modern approach to the old masters. The eighteenth century produced copies of excavated artifacts that were meticulously true to detail. Today we want to immerse ourselves in the style of painting; we want to compose a world of images to fit rooms with modern furniture. The chapter on painting in the style of Pompeii does not consider the scientifically accurate reconstructions of archeological artifacts. We want to create an overall harmonious experience, a convincing impression.

We have only touched on the big theme of ancient and modern Italy. To stage a virtual world, to examine our cultural heritage, demands each artist's own response.

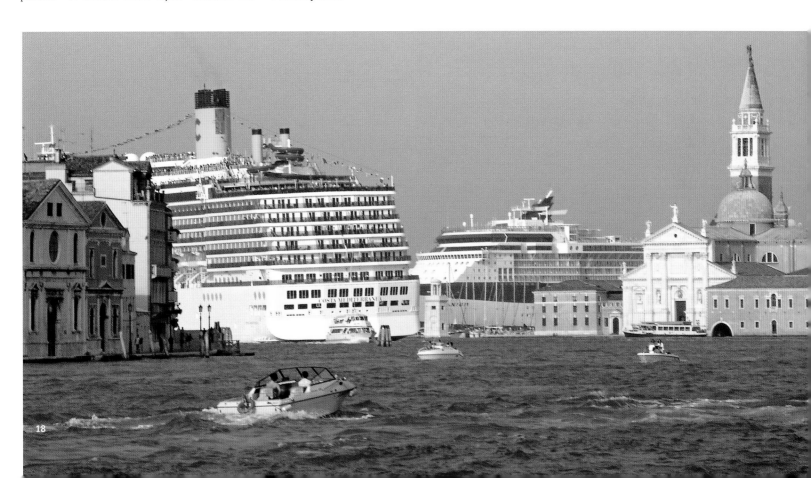

2. Pompeian Frescoes

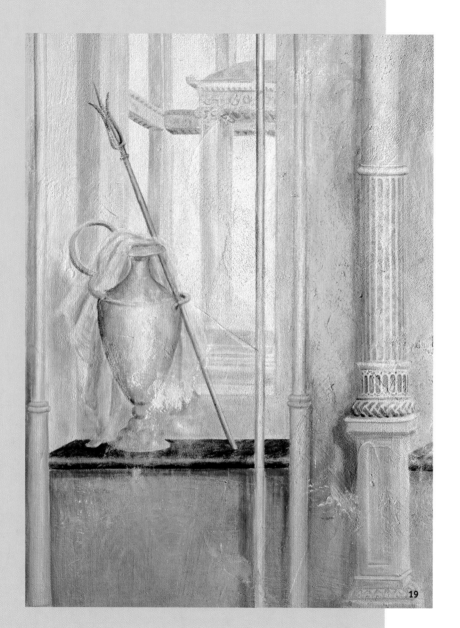

19

The four styles

Since the eighteenth century Pompeian style paintings have been beloved in Europe. Pre-Christian paintings, discovered through excavation, were considered sensational because of their illusionistic and perspective representation. The motifs were copied and recreated. The painters tried to match their work to the style of the time and the demands of the monument to be decorated. The paintings introduced in this book are not accurate copies of historical models, but creations that use ancient motifs in the Pompeian style. Two thousand years ago, when the original paintings were done, we might have found similar improvisation, because out of thousands of decorations none repeated itself. A few basic shapes and countless combinations defy categorization.

Pompeii mirrors the style development of Roman art. When we talk of Roman murals, we often refer to paintings from Pompeii and other Vesuvius towns like Herculaneum and Stabiae. The region became a Roman colony in 80 BCE. Wealthy Romans built expensive mansions there. We find the most beautiful artifacts in Pompeii, perfectly preserved through Vesuvius's ash rain in 79 CE. These paintings remained untouched, with hardly any deterioration, until excavation. The first systematic excavations in Herculaneum changed all of that.

At the end of the nineteenth century we started to distinguish four style epochs dating from 200 BCE to 79 CE. Those who wish to paint today in the Pompeian style need to know about these epochs.

The "first" or "structured" style (circa 200 to 80 BCE) incorporates a method of marble imitation common in Hellenistic Greece. The walls, simply constructed with inexpensive material, were covered with stucco, then treated, painted, and polished. This created the impression of large, sculpted, carefully chiseled stone blocks and a well-thought-out architectural concept. The walls are divided horizontally into three parts. A base of large panels or ashlars sits above the dark base. Small rectangular cuboids seem stacked up above them in regular horizontal layers. On top we find a white stucco cornice. At times, a painted faux loggia with stucco half-columns might be above the cornice. Door and window frames, pilaster strips, and corbel stones were also done in stucco and painted as stone.

The "second" or "architectural" style (until 20 BCE) continues the tradition of paintings done for Greek theaters. Wealthy Romans imported the style after colonization. They felt the need to compete as far as luxury was concerned. Elements of the first style were taken over (for example, horizontal wall trisection). These elements were painted and no longer covered in three-dimensional stucco. Perspective architectural views were added. Columns and pedestals seem to stand in front of the wall. They separate the wall into three parts and carry the architrave, arches, and the coffered ceiling. We get the impression of a three-dimensional trisectional stage set. Here painted architecture enters into a relationship with the actual (column) architecture of the room. In the middle part of the "stage," a door is added. It is open, revealing a view of gardens, colonnades, and mythological nature scenes. Later, on the left and right side, doors were painted "opened" to show illusionistic views of architecture, landscape, and gardens. On miniature stages, life-sized figures act in mysterious or naturalistic ways. Instead of faux marble we find color. The walls are painted red, yellow, black, or white (less often blue or green). Small pictures are presented on these colored areas. They rest on painted feet of candelabras or cornices. The center holds large figures framed by temple-like constructions. This suggests passage to the third style.

The "third" or "ornamental" style (until 60 CE) aims for formal balance and simplification. Emperor Augustus favored the classical Greek taste for fixed shapes. The faux architecture seems imprinted on the wall without great illusionary depth. It takes on an ornamental shape. Freed of realistic restraints, the painting becomes stylish decoration and representation. The painted columns don't have to "carry" anything; they become thin filigree, plant stems and candelabras. The architectural painting in the upper part of the wall is miniaturized and fantastic. The middle is a frame for the "actual" figure. It is expertly painted, of extraordinary quality, and often shows a scene from Greek mythology. The horizontal trisection is now the binding, rationally divided, overall frame. Large, single-colored areas are decorated with filigree borders, ornamental ribbons, small columns, and candelabras. Friezes look like marble inlays; small pictures in a sort of miniature painting show landscapes and figures. Vibrant colors, considerably different from the black and white background, are preferred. Egyptian motifs become very fashionable.

Next to the third style for today's mural design, **the "fourth" style—the fantasy or illusionistic style (from 50 to 79 CE)**—is of most interest. After the earthquake in 62 CE, many houses needed renovation, so the style blossomed during Pompeii's last seventeen years. The style brings a tremendous development of illusionistic possibilities. The wall, as in the three previous styles, is divided into three distinctive parts. The colors of the multicolored base become lurid and full of contrast. We see temple-like mounting constructions, inlaid pictures, statuettes, small landscapes, and simulated reliefs. At times, the midsection changes into some sort of stage for complicated, fantastic, architectural playfulness. Many vanishing points draw the eye here and there, confusing rather than drawing the viewer into a homogenous faux room. Here, in the center of the wall decoration, we find people floating in space, or set into medallions, also genre scenes or landscapes done in a lively, almost impressionistic painting style with striking light and shadow effects. In the upper wall, perspectives become even more complicated and obscure. These strange compositions do not consider logic or structural analysis. They

Fantastic architecture

seem like a ludicrous fantasy world emerging from behind the wall. The lower wall shows marble pedestals and gardens protected by painted gates. Where polishing of walls, waxed in true fresco style, dominated since the first style, polishing is now either reduced or left out with these inlaid figures. This intensifies the impression of seeing countless levels of reality in front of us.

The wall design in figure 20, inspired by the fantastic architecture of the Casa delle Vestali and Pompeii's Villa Imperiale, shows the attractive possibilities of the fourth style for today's interiors. Three "windows" in the wall reveal a theatrical stage set, thereby opening up an illusionistic room "behind" the red wall space. The mural makes the small kitchen look larger. The farther

in the background the architectural elements are, the paler are the colors. In the center of the architectural depiction, in the hard-to-define front part of the "back room," a female figure stands on an ornamentally decorated candelabrum (figure 21). At first glance this statue is connected to the faux room; at a second glance we recognize the contradiction in the image. These composi-

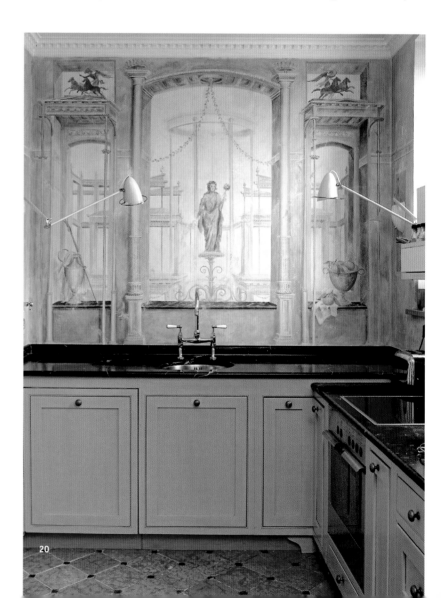

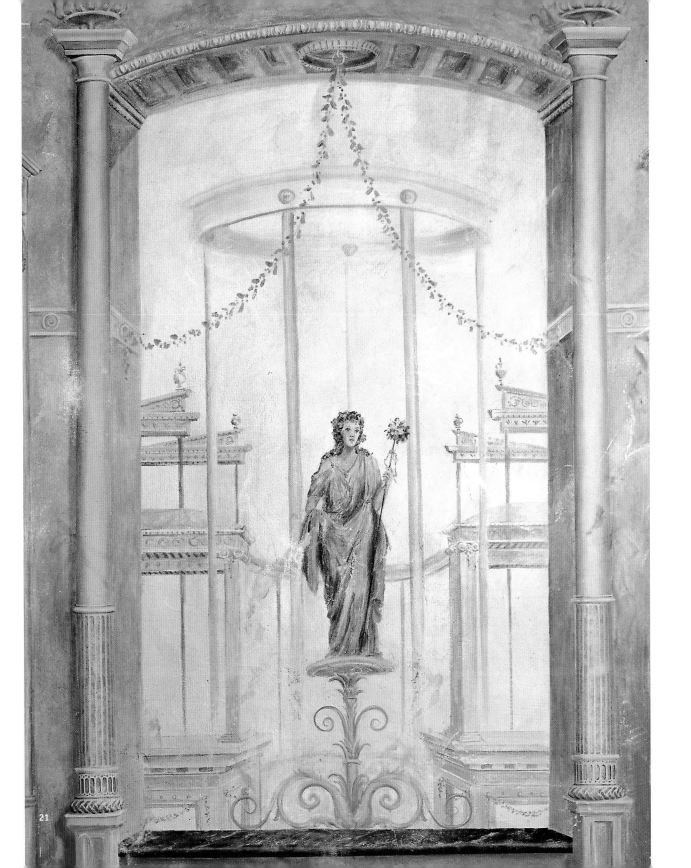

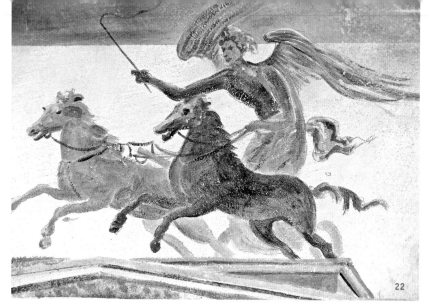
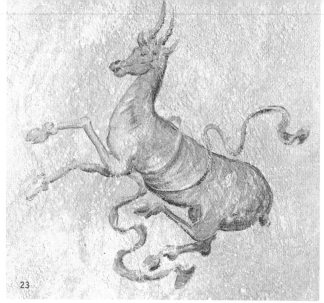

tional contradictions are intriguing. They invite us to look at it over and over. If the "statue" is made of stone, how could it have a filigree ornament for a pedestal? The painted depiction of the female figure does not appear stonelike. . . . How tall is she? What is the spatial relationship to the columns with the round crown and how are they connected to the faux architecture? The mix of seemingly correct perspective and iconic figure representation together with decorative ornaments challenges our common ways of interpreting art. Our overall impression is that of a rather mystical world.

The filigree architecture with its columns and riders carrying a baldachin continues into the room on either side of the wall. Here it becomes more tangible. Its design is finer, more concrete, more in harmony with the filigree brackets of the real wall lights.

The wall itself becomes a theme "broken open" by windows. The window embrasures show the real thickness of the wall. The window sills are painted like marble—the same black marble as the kitchen workspace. On the left, the oil carafe

with lance and fabric is composed as a decorative still life (figure 19) and, like the fruit bowl on the right; it seems almost a real kitchen utensil. But the Sun God with chariot (figure 22; the original motif is in Herculaneum's Collegio degli Augustali) is just as ambivalent as the female figure. Are these statues, real people, or mythical figures?

The fourth style fascinates us with its mix of different levels of reality combined with illusions. We are unsure. Are these trompe l'oeil paintings, mythical scenes, still lifes, or allegories? Not only do we find different painted levels in a three-dimensional room, but also different levels of meaning.

In the design of this kitchen three aspects are important:

1. The painting does not depend on a realistic representational color scheme. Therefore it can use colors that match the room. The three main colors—Pompeian red, earth green, and cream-white—match the colors of the marble floor and the furniture.

2. Thanks to the fantastic architecture, the natural horizon of the landscape is unimportant. We look outside, not into a real landscape, but

into some sort of stage set. The "view from the window" usually separates murals into landscape and sky. The fourth style allows all possibilities. We can be free in how we handle the principles of perspectives without giving up on them entirely.

3. The base has been pre-spackled with a sandy, paste-like, casein-based coating plaster that is smoothed out at times and at other times left with its grainy consistency. This natural material seems like stone. Even after it is painted with acrylics, it can be sanded and chiseled to create traces of patina. The wall now appears old and historic. Although done with acrylics, the painting seems close to a real fresco.

We can recognize the rough base coat highlighted in figure 23. The "flying goat" is on the opposite wall. The wall is sparingly decorated with illusory coffering and fabulous creatures.

Another part of the room shows a pale-colored interpretation of the well-known fruit bowl from the Villa di Poppaea in Oplontis (figure 24). Two different vanishing points are used for the same representation. This might irritate us in the photo

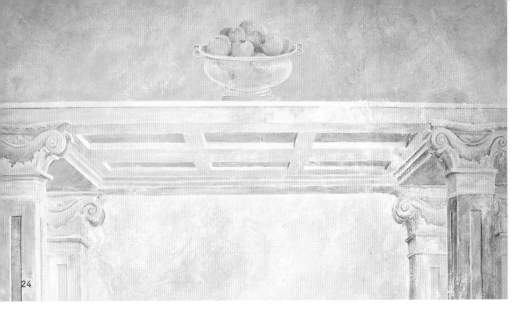

reproduction, but it does not on the wall. Here the bowl is perceived as reference, not changed in perspective. In a realistic construction of the fruit bowl at a height of 10 feet (3 m), we would hardly recognize it. Such realism doesn't make sense. Who places his apples so high and unreachable above his head, outside his view? Pompeii's artists were free in their use of perspective.

Figure 25 is an interpretation of the bowl in its original context and original colors. The entablature is shown from below, the bowl from above.

The sketch for figure 26 had been created for a staircase. It was inspired by elements from murals found in the portico of the Domus Aurea (Rome.) A design in the fourth style is especially well suited to staircases, where the viewer's perspective constantly changes. In the upper part of the 23-foot wall, figurative elements are effortlessly portrayed in proper perspective. "False" perspectives have to be done especially accurately. The depiction of the impossible has to be realistic so that the viewer believes it is real. This contradiction keeps fascination alive. The festoons, statuettes, and draperies don't force themselves into the foreground, but

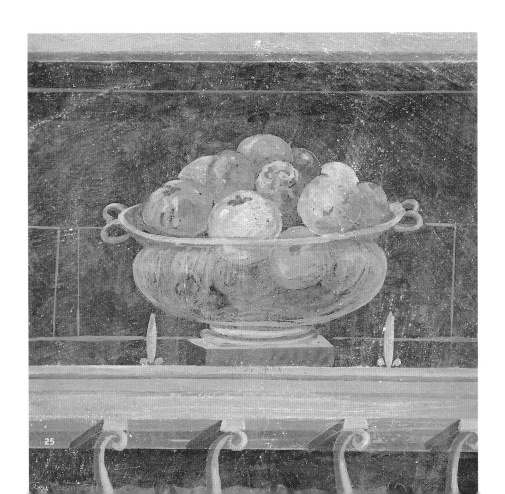

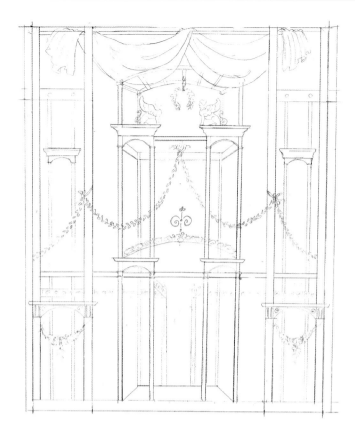

26

help to open up the imaginary "back room." Done in pale, weathered colors, such a wall fascinates the eye without overwhelming it.

The architectural representation is shaped by clear, graphic elements; the floral and figurative elements on the other hand seem playful and decorative. No other composition device allows us to combine playful softness and graphic strength. We can work with all room proportions this way. There are no problem rooms—rooms that are too high or too wide—for the fourth style.

27

Changing depth of field to two-dimensional ornament

A series of panels were painted for a trade show display and for window dressing. These panels can be combined in different ways according to length and height of the wall (figure 27). In the middle is a filigree column construction with canopy and lions "this side" of the wall; to the right and left windows open the view into a world "beyond" the wall. The motifs for the monument's backdrop are taken from the Pentheus room in the House of the Vettier. An ornamental pedestal can be added depending upon room height. Special patinaed fields in the left and right corners can be extended as needed.

In each building, there are walls we pass unaware and walls in our field of vision we pay attention to. Accordingly—as in the above example—delicately differentiated room illusions can alternate

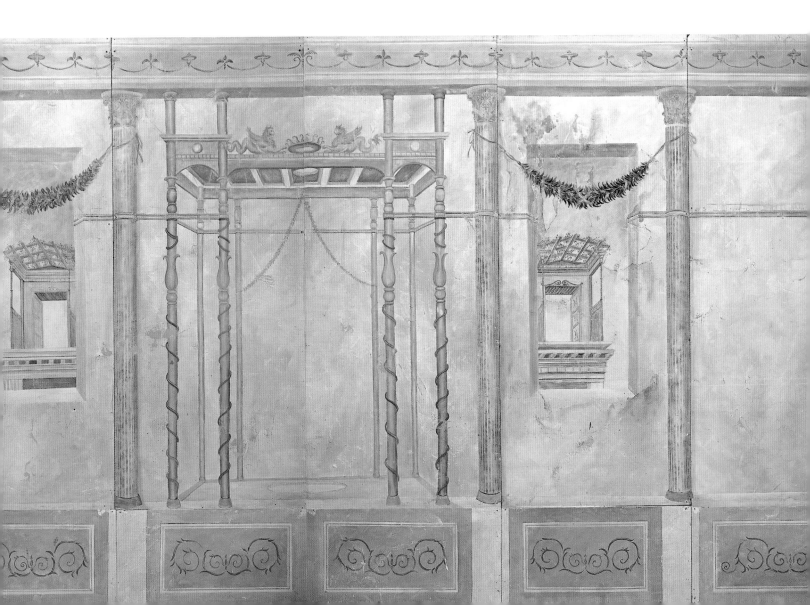

28

29

with decoratively designed color spaces. Different styles have been used in the exemplary design of a staircase (figures 28–35 show its condition at the beginning of the work). The entire painting invokes three main images. The images at the two front walls belong to the fourth style (above) and second style (below). The image in the foyer shows a clearly formatted backdrop painting in the second style. The special two-dimensional color design of the horizontal wall is structured in the third or ornament style. Figure 29 originated during work on the horizontal walls. The candelabra-like plant stem would later "carry" the wall lamp. In the lower area, its outline is traced onto the wall; in the upper area it is already painted in.

The palette hung on the wall with sample brush-strokes from the mixing of colors shows how important small nuances are. The pinned-up sketch shows the calm vertical division of the wall into areas set apart from their frame tone-on-tone. In the painting's execution (figure 30) we gave up the blue candelabras. They would have brought too much disquiet into the small room.

The main image of the upper front wall shows a mythological female figure with a cornucopia. Tangible architecture portrays her as immediately "behind" the broken-through wall (figure 31). Defying all laws of structural analysis, a golden winged sphinx, inspired by the Triclinium's west wall in the Villa Poppaea in Oplontis, sits above her head.

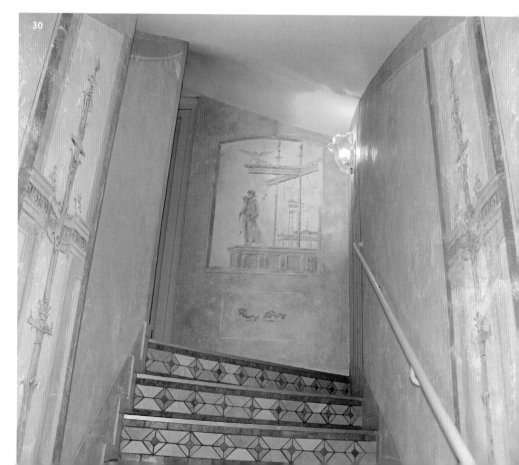

30

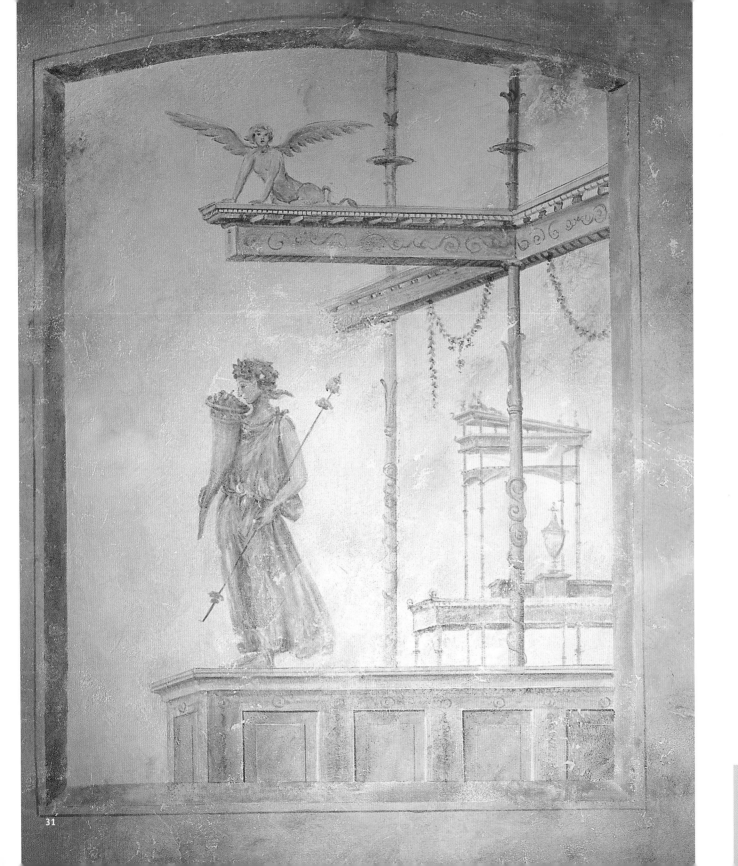

31

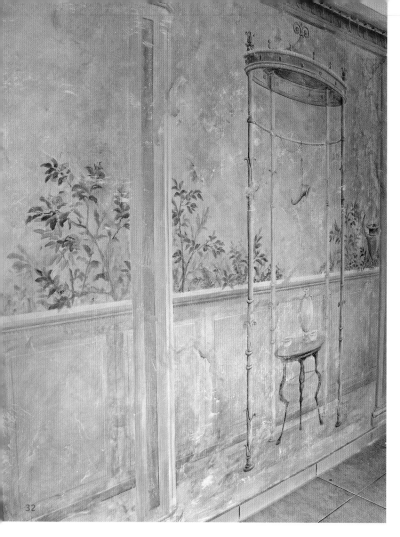

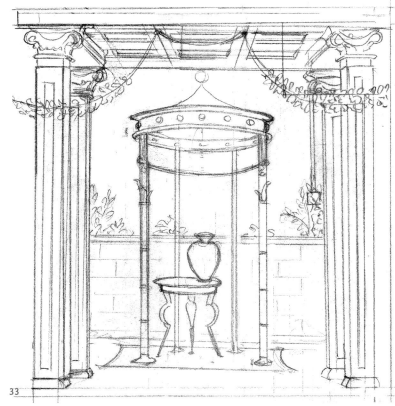

Its lifelike qualities and the filigree architecture floating in the background puzzle the viewer.

The main painting in the foyer diagonally across from the entrance door opens the wall to an imaginary view, but shows rather calm and carefully arranged architectures (figure 28).

How different the painting at the bottom of the stairs (figure 32). We find a small pavilion with a carafe on a table. The pavilion is framed by colon-nades that carry a perspectively correct beamed ceiling. A small wall separates the painting into fore- and background. Behind the small wall is a veiled fantasy garden. A few branches above the wall allude to the garden (figures 33, 34). When the precisely rendered pavilion is done (figure 35), exact contouring of the foreground lends authenticity to the representation; the garden seems even more enchanted.

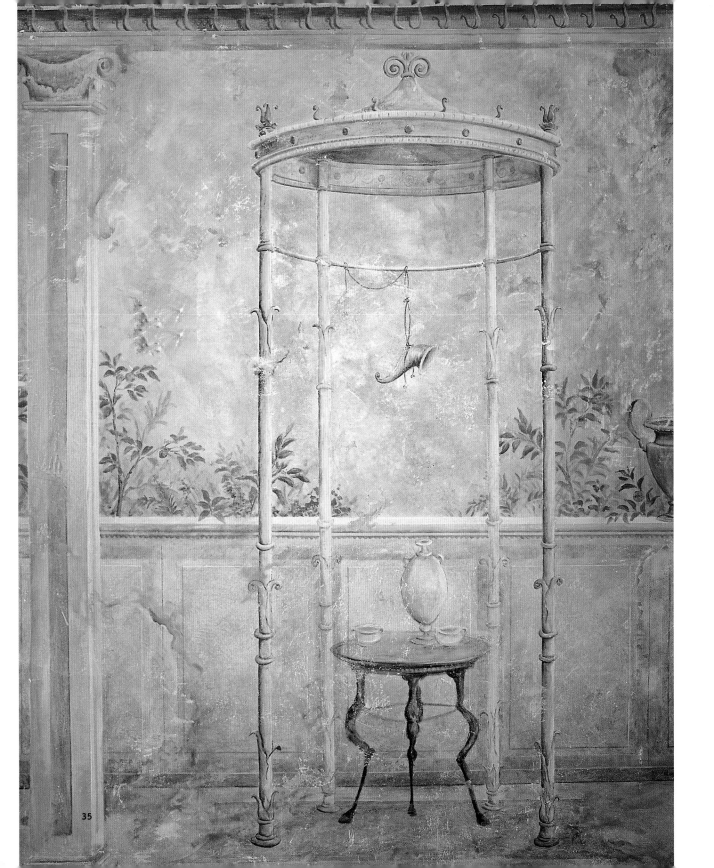

35

Ornaments

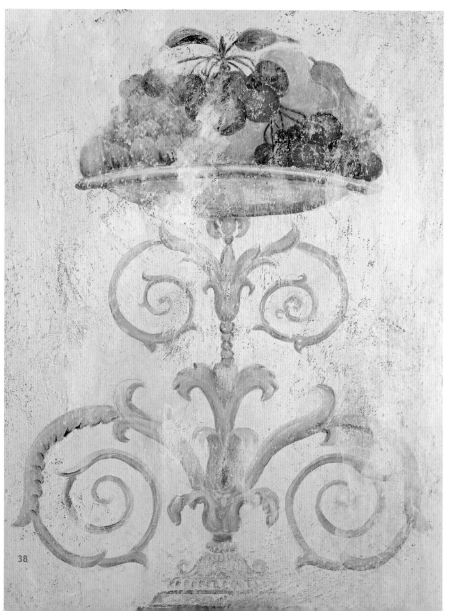

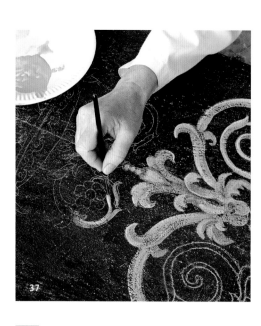

Figures 36 to 38 show the practical application of ornaments in the third style. First we use templates to do a black-and-white outline drawing; then we trace it onto the underpainting with graphite paper. The template (figure 36) for the fruit chalice was inspired by an Italian decorative painting imitating Pompeian mascarons (grotesques). We treat the underpainting with a thin layer of pasty coating plaster to which a little sand added. Then we stripe it more or less evenly.

We can partially keep the porous relief structure, because we want the surface to look weathered

36

37

38

39

40

41

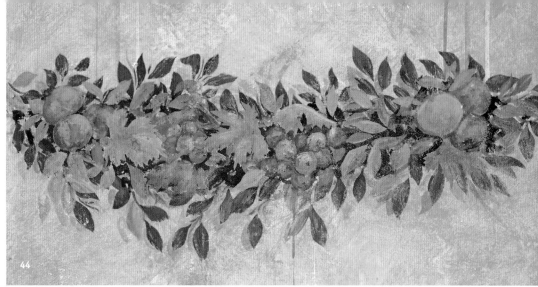

44

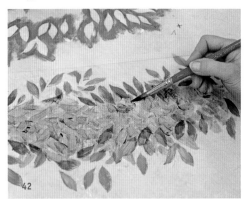

42

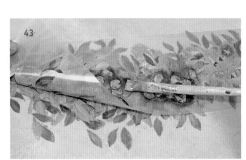

43

later on. After the plaster dries, we underlay a thin, strong color glaze that penetrates the relief. In figure 37 the underpainting is strong ochre-yellow. Then we use a trowel to apply the colored background (here it is black) with relatively dry, slightly granular acrylic paint, to achieve an irregular coat. We trace the pencil underdrawing onto it (this is easily done with white chalk paper on the black background. We place the stencil over it and trace it line by line with a ballpoint pen or pencil).

The painting is done fast and freehand which gives it a fresco flow. The paint stroke follow the shape of the ornament. At the end, the painting partly treated with sandpaper, so that either the dark background or the sandy-white plaster becomes visible. In figure 38 the primer is burnt sienna and ochre with a little white on a champagne-white background. The painting can be partly filled in

with the color of the primer. We use the paintbrush for sharp contours and a natural sponge for two-dimensional, partly covered "missed" parts. With a black background, we can wipe up vertical run marks with semi-covering white glaze; they represent traces of descending water. The balance between accurate ornamental painting and seemingly chaotic destruction creates the desired antique effect. The detailed ornamental design and its deconstruction in the course of time create a charming contradiction.

Likewise, the festoon in figure 44 is created on lightly structured ground. This is not sanded in the end; we use spackle instead. It is more elastic, less rough than casein plaster. We paint with the help of three stencils (figures 39–41) inspired by a decoration in the House of Livia on the Palatine in Rome.

(There are similar festoons in the Villa of Publius

Fannius Synistor in Boscoreale and other houses). In figure 44, the underpainting, glazed in polychrome ochre and sienna, was treated with stylized bossing.

We do not dab through the stencil with a stippling brush, but paint freely with a small brush. The stencils ensure that the leaves are placed correctly and that their contours are in the right margins (figure 42). The first stencil is painted with the darkest green, for the leaves that will appear farthest away. Next we apply a lighter shade to the brush to give the leaves three-dimensionality and demarcation. We paint the middle part of the festoon freehand. For the stylized leaves, we use transparent Payne's gray mixed with a transparent glaze. The color should not be too dark, so that it does not darken the color of the leaves and fruits added later. It can-

not be too bright either, because the festoon should appear full.

We use lighter greens in the second stencil (figure 43). Most of the grapes are done with a grayish violet to which we can add carmine as needed. The missing grapes, grape leaves, and pomegranates (in ochre, burnt sienna, and grayish green) are used for the third stencil. This way we can distinguish even single grapes. For the two-dimensional grape leaves, we use a stippling brush to apply the lightest shade of green. Light streaks are painted freehand onto leaves and grapes. At the upper and lower edge of the festoon we paint the shadow of some leaves freehand and use the same Payne's gray we used in the center. The shadow makes the festoon stand out from the wall three-dimensionally.

Mosaic

Roman mosaics show a variety of ornaments and motifs. Today we are still fascinated by the austere shape and three-dimensionality of geometric braided bands. Here we show how to do a stylish imitation of a mosaic with the help of stamps cut from synthetic sponges.

First we choose a simple design, a repetitive grid to be measured on the floor or wall and drawn in pencil. We cut and shape the stamps accordingly and stamp using dry paint sparingly. We do not try to depict high-gloss glass mosaics or new tiles bought at Home Depot, but old weathered, dirtied, and shifted tesserae.

The overall picture becomes livelier when we see the base coat color not only through gaps but also partially through the tesserae. In painting floor mosaics we predict wear and weathering (figure 45).

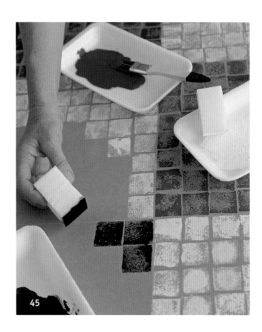

45

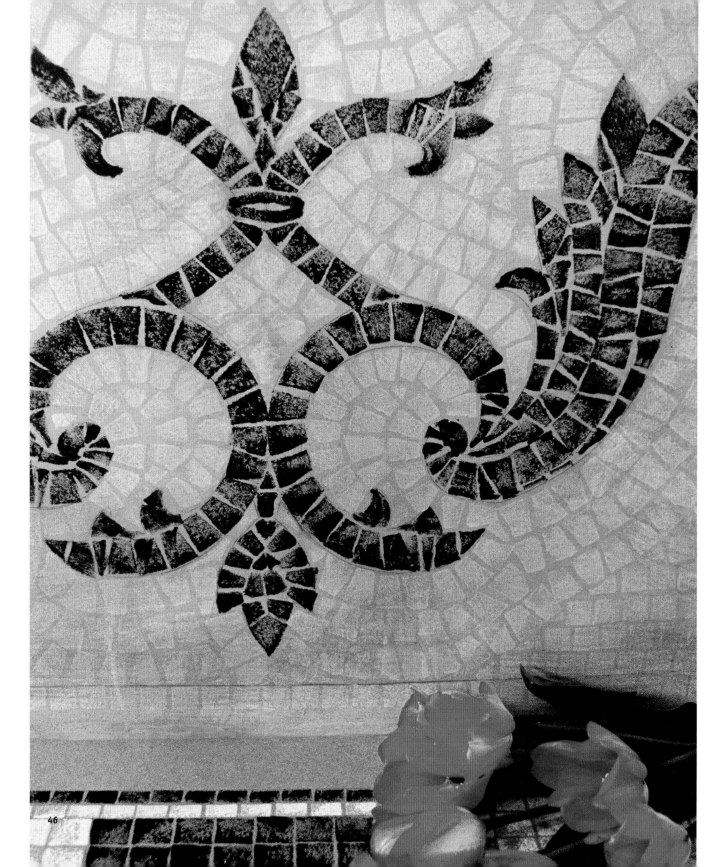

The balcony floor in figure 51 is stamped with a resin-based cast plaster color. The sprinkling of terracotta stones into the graphic interplay of dark gray and uneven white is charming in this easy floor design.

We create trapezoid, rhomboid, and triangular stamps for the wall design in figure 46. The minimal color contrast between light tesserae, base coat, and the broken color application even with the darker shades prevents us from seeing the wide gaps. (We would not have forgiven a professional mosaic layer these gaps.) The finished stamped area is washed over with a turquoise-gray glaze. This unifies tesserae and base coat.

Figures 47 to 49 and figure 51 show how we can transform a sad concrete balcony into a Pompeian veranda using a stamp mosaic (floor), ornament template (balustrade and foundation), and painting in the third style (wall midsection). We use a yellow underpainting for the red base coat and its green frames. It shines through and combines all colors. A transparent light-gray shadow almost covers the entire image and adds coolness to the colors. The wall appears older than it is: we can achieve this artificial aging with fine sandpaper also.

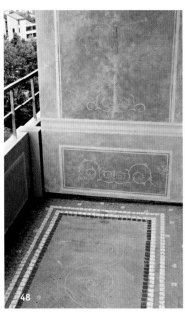

50

51

Landscape and Vegetation

Landscape painting

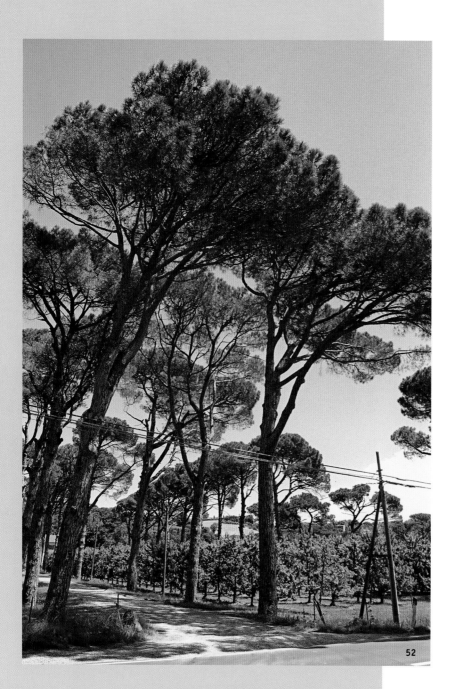

52

The development of landscape painting owes much to the discovery of Italian landscapes by seventeenth- and eighteenth-century artists. These artists were mostly interested in three regions: Rome and its surroundings, Naples and the Amalfi coast, and Sicily. The paintings of that time portray mostly idealized landscapes. They seem lost in reverie about space (idealized composition and mood) and time (depiction of ancient buildings). Similarly, today's murals should evoke dreamy longing. If the distance between the painting and the viewers' life circumstances is too great, the longing runs empty and the image appears strange. We suggest that places and moods should not be too far removed from the viewers' reality. Probably, this is why a different Italian landscape has been favored in murals: Tuscany.

Tuscany is diverse, but not extreme (figures 52, 53). It has great cultural and historical traditions, and at the same time we can simply enjoy it. Tuscany is nature, tamed and noble. We are aware of man's creations everywhere. Under ideal circumstances we do not experience them as destructive, but enriching. This is true especially for old towns, villages, and country houses that are part of this landscape: built with Tuscany's stones, its earth (for example, with *terra di Siena*, or Siena earth, named after the town of Siena). If the visitor can overlook the auto routes' billboards, the industrial areas, and new districts, the depleted, threatened forests, and impoverished nature, Tuscany even today is some sort of ideal landscape. If you want to see it under the best circumstances, visit in May when temperatures are bearable and the green is luscious. All the images of Tuscany in this book show landscapes from the middle of April to the

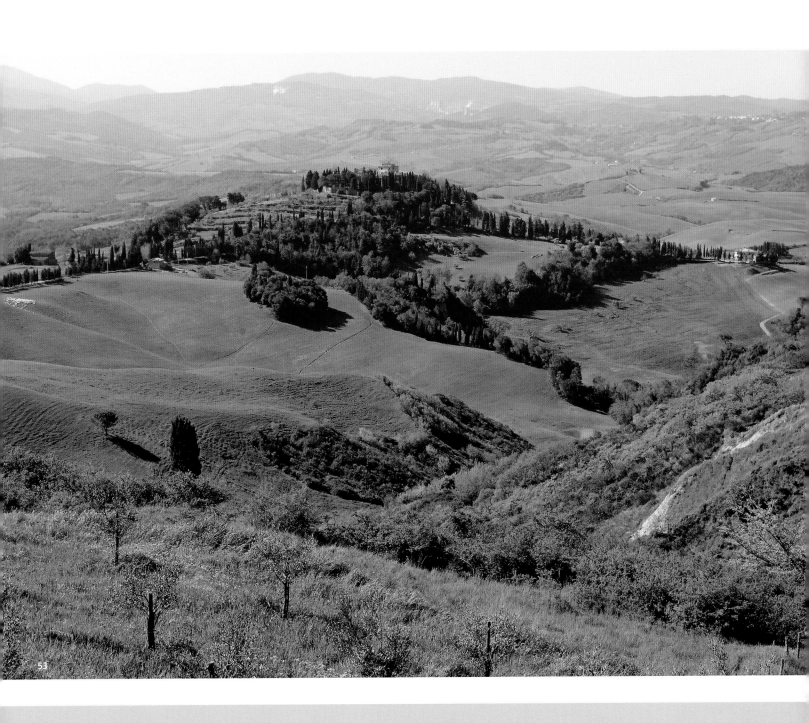

end of May. The trompe l'oeil painter should idealize Tuscany as everlasting spring, reminding us of regeneration, health, and immediacy.

We idealize not just the time of year but also the vegetation. In Rome umbrella acacias are the most striking trees. In Tuscany the cypresses that line the roads like dark sculptures are most striking. For mural painting cypresses are big challenges. Their color is rather dark; their massiveness obstructs our vision (see figure 68, page 50). Backlighted, they are inappropriate for murals. We have to move them into the right light, brighten their color, and refine their raw, closed shape with multiple color nuances and playful light.

The picturesque small road in figure 71 (page 51) is shown in countless calendars and almost every book about Tuscany. It embodies the cypress-lined Tuscan serpentine road although such a dream scene is rather exceptional. The rolling, poetic, meandering path leading up to the country house in idyllic nature does exist in reality and not

only as an archetype. Here it is possible for dream and reality to meet. Tuscany is famous for its light of transcending transparency, its fragrant mornings and evenings. How different from Sicily's and even Rome's hard shadow! In many murals "Tuscan light" becomes light ochre at the horizon. It has to be delicately glazed on a brilliant white wall so that the yellow glint does not feel harsh, but like a transparent veil.

Improvisation (working with the unpredictable) is the origin of many artistic designs. Improvisation can be dangerous if we have to do a trompe l'oeil painting for a specific room. We need well-thought-out design and execution. Nothing can be left to chance. We plan and discuss the work in great detail with the client. Before we start the work, we need to be clear about the architectural frame (i.e., a window, archway, wall, or balustrade), the height of the horizon, the base color, and the image to be represented.

The sketch in figure 55 involved a lot of planning to compose the architectural elements. We tried

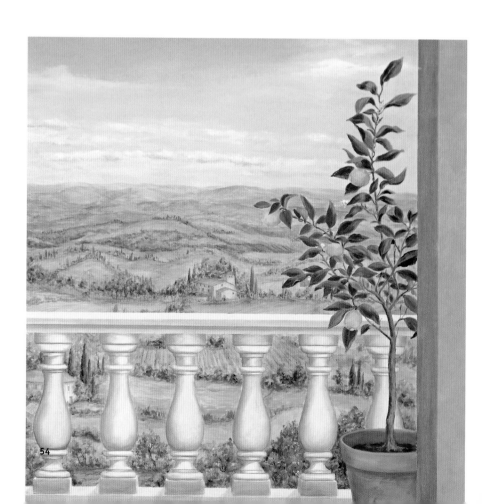

54

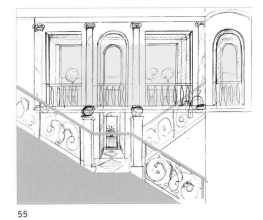

55

to incorporate a vista into a staircase. The existing staircase and future railing are shown in red; the rectangular corner (the walkthrough) is shown in dashed lines. We will later paint a lattice underneath the railing. The lattice will match the ornaments of other lattices and gates in the building. A second staircase to be painted includes railing and lattice: it starts at the landing and extends to the upper room. Then we create a connection to the painted loggia with a vista. The illusionist landscape motif is marked blue in the sketch.

We need to think carefully about the integration of architecture and perspective when we design staircases where the viewer's viewpoint shifts constantly.

Once we have planned the landscape, we can work on it in an interplay of composition and improvisation. Sketches and photographs are a great help. Free, generous underpainting makes for a

spontaneous flow that flow is still evident in the painting.

Figure 56 shows what is important in application and underpainting:

- Geometric and color perspective (aerial perspective) go hand in hand. We need to know this to achieve a credible diminution of the objects without geometric construction. If a part of the landscape is in the foreground, we look at it from above (especially if we stand at an elevation). If it is in the background, we look at it from the side, as if it had been "pushed together." The lower part of figure 56 shows a depth of field of 984 feet (300 m). The house alluded to might be 820 feet (250 m) distance from the viewer. The upper part of the painting shows a room of 9 miles (15 km) depth! Near the horizon the distance between mountain ranges is minimal. We cannot point this out often enough: most mistakes occur here.
- We use warm, strong yellow-green tones in the front. In reality, grass is not so yellow, but light ochre brings green "closer" to the front and suggests fluctuating light reflection.
- In the back all colors are tinged by a mildly saturated milky blue.
- The underpainting shows no details. But everything is applied, the dimensions are correct. We can see at once that it is worthwhile to continue the painting. We are on the right path. If we were to get "stuck" at this stage, we would need to put down another white base coat and start all over again.

Landscapes embody change. This has to do with light. The sun's positions, the sky's color, and the clouds constantly change and with it the green of the leaves and the color of the shadows change. We should feel this liveliness in trompe l'oeil paintings. Figures 57 to 59 show us how to make this possible. First we sketch the landscape from nature or from a photograph and with chalk trace the most important lines onto the painting surface. Then we apply the base color of mountains, fields, forests, and meadows with free glazing brushstrokes. Through several semi-transparent layers of paint we can fine-tune the coloring precisely: the foreground should generally be done with warm colors, the background with cool colors. The expansive feeling that is always desirable in trompe l'oeil painting, is best created by glazing, for we work with the depth of light reflected through layers of paint from the white surface so the painting appears veiled. Less appropriate are pastel gray-blue tones when they have been applied opaque, thick, and relief-like. They lack the openness that bestows lightness and transparency on the figure. This is especially true for the colors of the sky: they are luminous when they emanate from the depth of light in the picture.

Once the first layer is applied, we can add more details from the sketch and trace it with graphite paper. At this state the overall impression of the painting is soft, open, and flooded by light. This impression should last throughout the last stage of painting (figure 58).

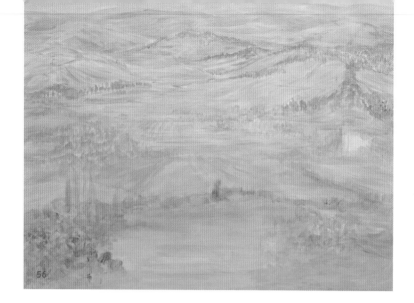

56

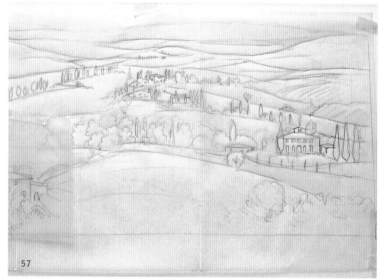

57

58

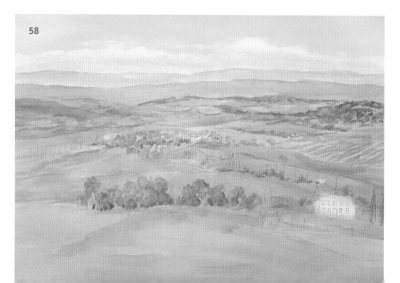

In the composition of the painting of the window with a yellow shade (figure 59), we work with strong spatial contrasts. The shade fills nearly the entire upper half of the painting. It comes alive in its delicate glazed, silky, changeable colorfulness, which lends an optimistic, happy mood to the painting. In contrast to the blue of the sky, an extended depth of field is opened, stabilized by the brown-red of the window frame. The delicate depiction of the landscape is only 10 percent of the painting; but the viewer's impression is that of looking at a landscape painting. It is unusual that the foreground details have been reduced; this creates a calm, relaxed overall feeling. The yellow mixed into the green foreground relates to the yellow of the shade and borders the brown-red of the window frame in the second foreground area.

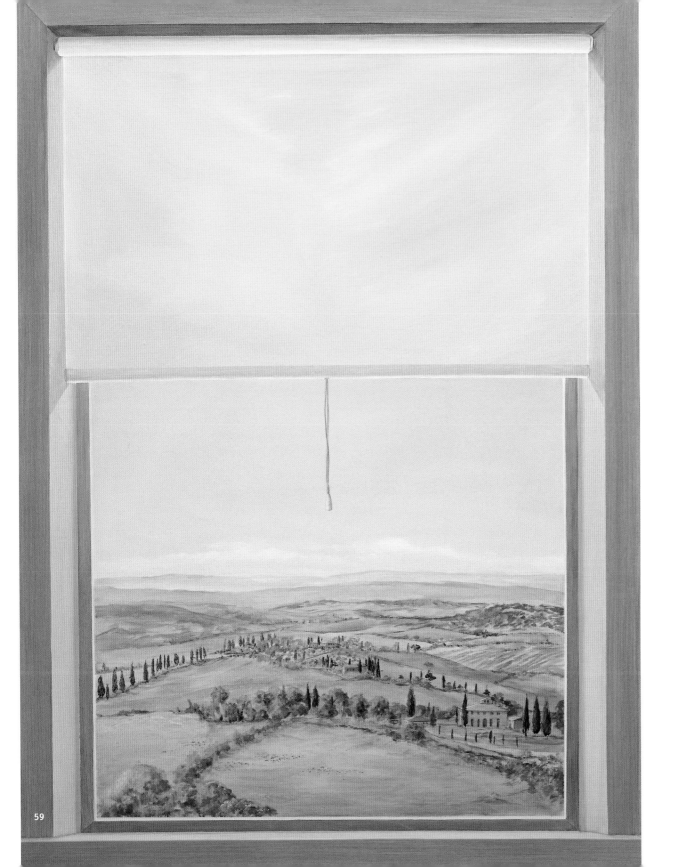

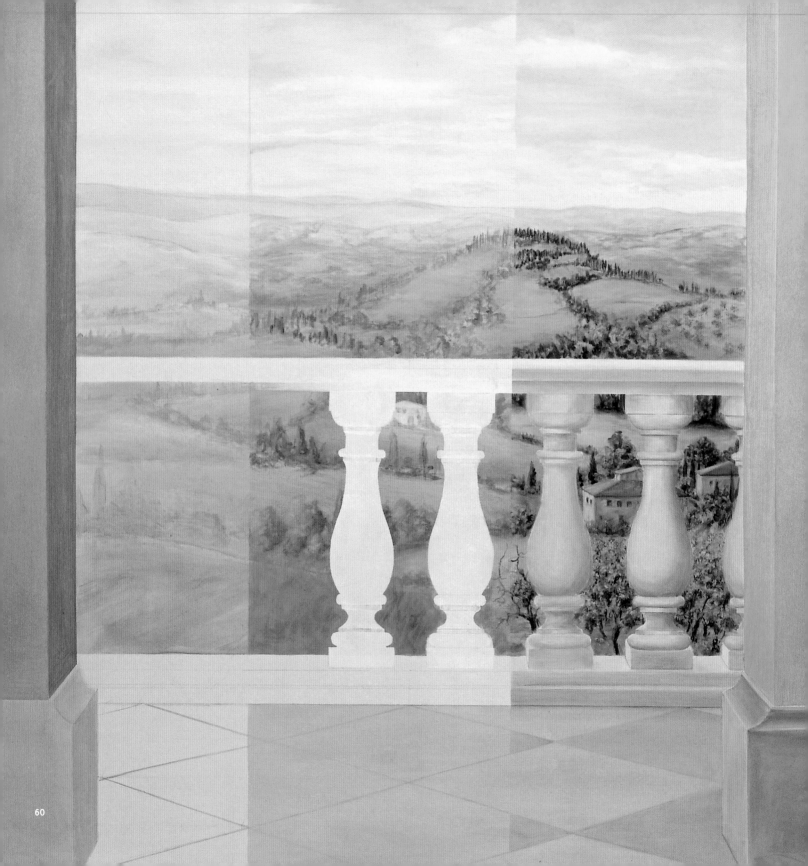

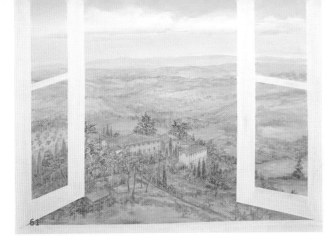

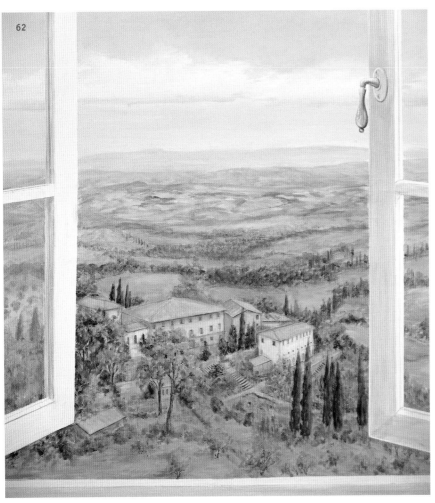

In figure 60 all three stages of the painting are summarized: to the left, the first glaze of landscape and sky; to the right, detail-rich, painted-in scenery. The doorway, the tile grid of the floor, and the balustrade are fixed from the beginning. But where and how the rows of trees rise, whether a field will grow olive trees or become farmland the painter will decide spontaneously. In the end, the strong light–dark contrasts create a succinct effect. Dark color nuances are used little by little. We hold back the contouring lines for a long time. Hard shadows and flashes of light are added last. When we use them too early, we cannot coordinate everything. We might create situations that do not fit into the overall painting. As nature emerges and a unifying light binds everything together, a landscape should grow until it has reached the final stage. Foreground details like the lemon tree in figure 54 (page 40) are added last with opaque paint and the strongest light-dark contrast. Figures 61 and 62 give the impression of a spatial presence. This is created as soon as the diffused, rather two-dimensional color of the underpainting is transformed into a detail-rich representational painting by light–dark contrasts and clear contours.

Guiding the viewer's attention

Successful trompe l'oeil painting is neither too complex nor too simple. The window with the yellow shade (figure 59, page 63) is a good example of how large, barely differentiated areas alternate with small delicately painted parts. They invite the viewer's eyes to roam. Watch yourself looking at the painting. You might rest your eyes on the yellow area, explore the brown red frame, turn your attention to the midsection and background, and then start all over again. You continuously switch from focused to peripheral perception, from color impression to shape recognition.

What we formally call distribution of mass in composition studies is, as far as eye movement is concerned, best described as guiding the viewer's attention. The special charm of the Italian park motif (figures 64 to 66) is its exciting composition. From the higher viewpoint, the garden looked at from above dominates the landscape. (We know right away that the cultivated garden belongs to the house for which the mural was painted). Sixty percent of the landscape/garden represents only five percent of the depth of field. This is a more extreme proportion than in figure 59, where we have already illustrated the phenomenon. Two different ways of depicting

nature are used. The garden appears orderly and geometrically exaggerated. Behind the house we see a small forest. The treetops show countless fine nuances of green, free shapes and transitions. Behind the forest that shelters the house from the rear wild nature begins, opening to a vista. Soft mountains disappear into a foggy horizon; we look into the distance. . . . But we cannot lose ourselves entirely in the dream. The window frames and hallway are in the way. They bring the painting into real space. The style and dimension of the painted window match those of the house's real windows. The edge of the un-

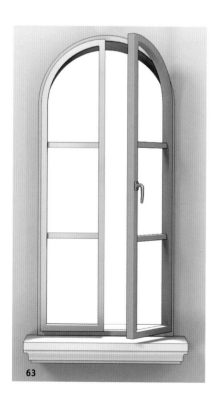

63

64

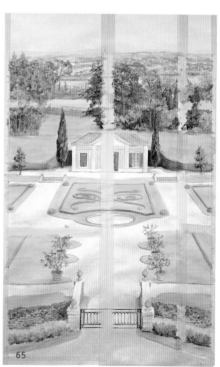

65

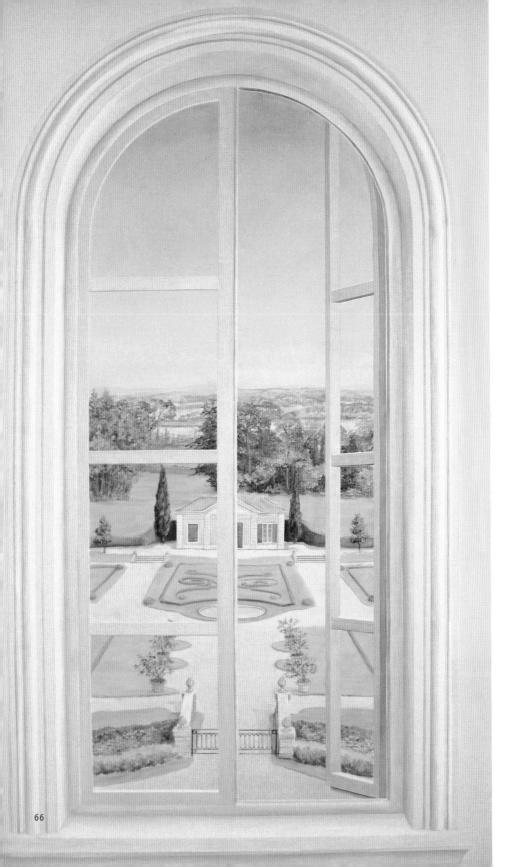

opened half of the window covers the middle of the house in the view. This makes the mural all the more charming.

When we composed the window painting, we suggested several versions to our client. There were different directions of the opening, different angles of opening, and different window encasements (figure 63). The painting was to be situated in a windowless connecting room with little distance from the viewer. The client chose the encasement opening to the outside. When window frame and landscape are mounted together from two templates, the heights of the horizon and vanishing point have to be identical in both templates.

Many trompe l'oeil landscape paintings are unfinished in two ways. First, the painter holds back in painting nature in its actual intense colors. The painting, especially if it is glazed, is always brighter, less saturated than in nature. Hard shadows are not painted graphically succinct, as in photorealism. When we see the sun's direction three-dimensionally, we can paint hard shadows. We need to leave room for dreaming. We animate the viewer to follow the painting actively so that the process of awareness unfolds successively in time. This is only possible with the fine coordination of various elements and painting techniques. This is what distinguishes trompe l'oeil painting from photo wallpaper. It is not exaggerating to say that illusionistic painting is only partly a representational form of painting. Configuration of movement and attention are similar to non-representational painting. This way the painting stays interesting for a long time even when we

Trees

no longer delight in identifying the objects. Nature becomes an image through the viewer—as modern theories of perception declare. The mural becomes an image of nature to its viewer, and, independent from its meaning, it vanishes in the movement of looking.

To summarize what we have said, we illustrated our words with the picturesque Tuscan serpentine (figure 71): strong contrasts and intense, warm, dark colors in the foreground; cool light colors and unfocused flat shapes in the background. The attention of the viewer moves back and forth between. In looking, an imaginary depth of field opens up.

Of the countless varieties of cypress trees, figures 67 and 70 show the two most widely familiar. The severe, closed cone-shape in figure 69 does not allow us to look into inside. The trunk is only visible at the bottom of the tree:

- In our chalk underdrawing we position the limbs like fans, the largest below, smaller ones above. We need to paint in a lively, slightly asymmetric flow.
- We begin to paint with the darkest parts representing the shady, most remote parts. Dry paint is brushed on with frayed brushstrokes.
- After the first layer has dried we add texture in light shades of green. The light side needs more work than the shady side, where more dark areas remain.
- In nature, cypresses are dark green. We glaze them yellow-ochre. This makes the colors stand out and more interesting. We achieve sunny warmth this way.
- In the end we lighten and set apart the highest parts with ochre and white. The rich details should match the delicacy of the entire painting. Where the original large fan shapes have harmonious proportions, differentiating is easy. We continue to work from large to small until we are pleased with the result.

When we add soft colors to the brown trunk, we can clearly distinguish its sunny from its shady side.

67

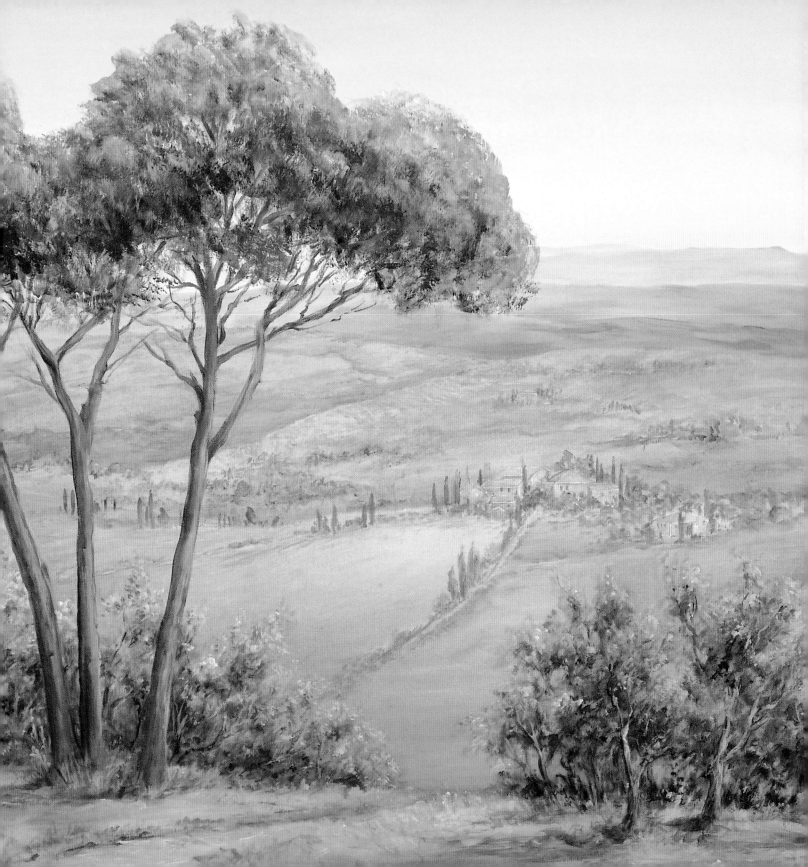

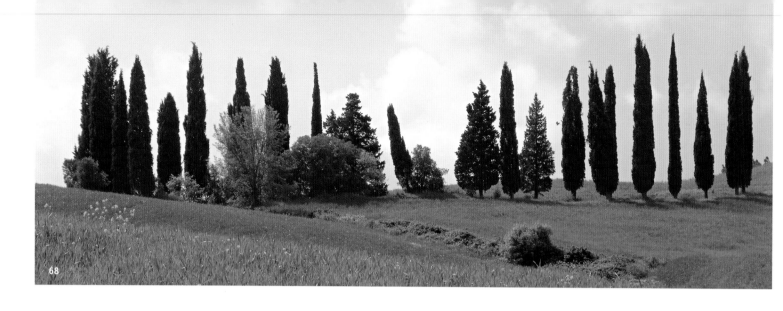

68

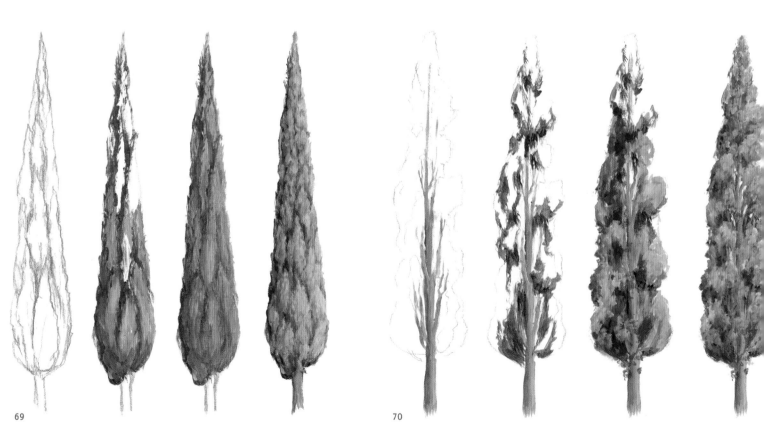

69

70

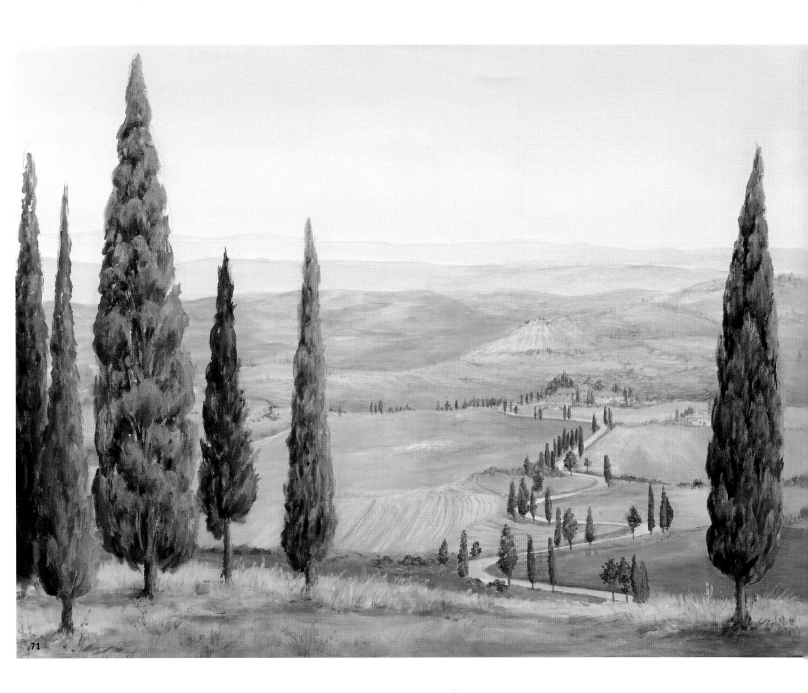

71

72

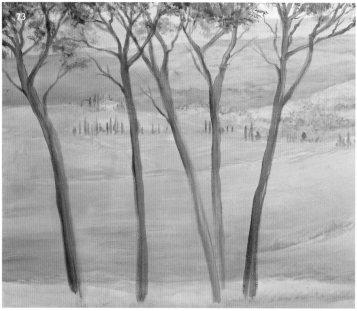

73

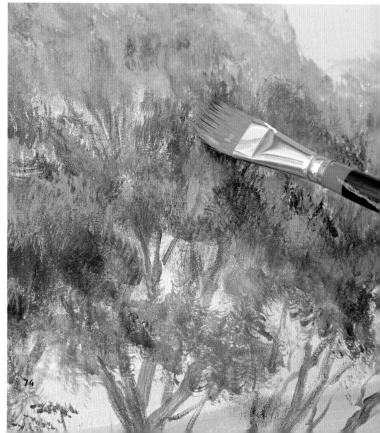

74

The overall impression of cypresses in nature is dark. In photos they appear blackish dark- green; backlighted, they are almost black. We have to add them carefully to the painting, thereby lightening their darkness. Trees in murals should be lighter than in nature. Especially pine trees; evergreen cypresses should not only be painted lighter and brighter but also warmer, so they fit better into the mural, which often has a friendly, open character. The cone shape of the cypress is loosened up when we can peek through its limbs (figure 70). This softens and lightens the closed shape.

- In our pencil underdrawing we need to be aware of the cypresses' irregular, asymmetric, and ragged outer shape. After sketching with chalk we paint the trunk and the slender main limbs close to the trunk. Pay attention to light and shadow. The limbs give the tree structure and differentiation; later, green will grow around them. The shape of the limbs should still be visible through the green. We have now created an organic overall impression.

- The limbs are painted in shivering motion with dry dark green, so that a free flow is created. The dark green represents the shaded areas, not the outlined shapes. Therefore we cannot frame anything. The colors have to be applied "frayed" and sparingly, so that we can peek through the limbs later. We also save ourselves the work of covering dark areas with light colors.

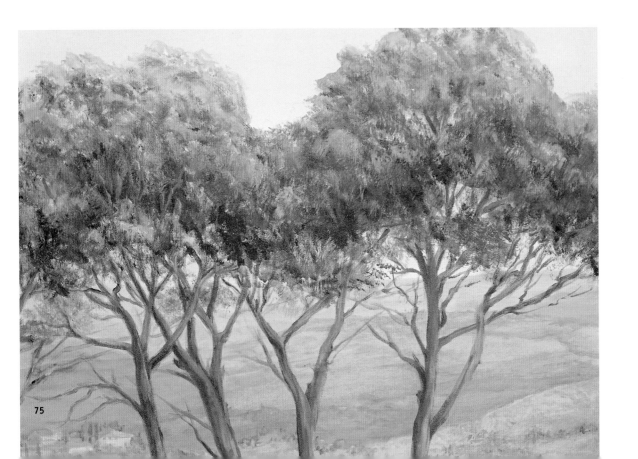

75

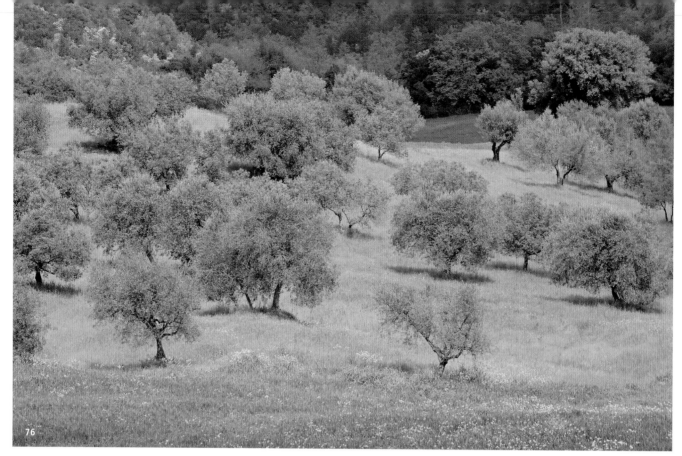

76

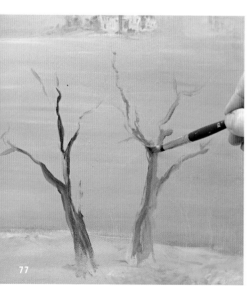

77

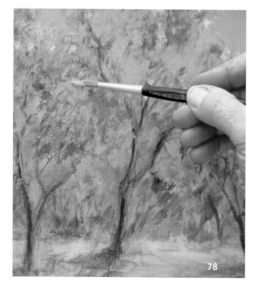

78

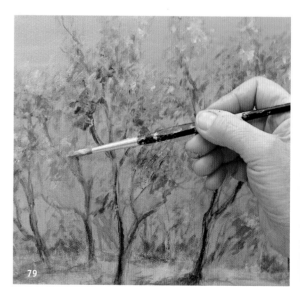

79

- Be careful with the lighter greens and yellow-ochre. Do not paint in everything! The background has to shine through; the sculpted trees have to be recognizable.
- To strengthen the three-dimensionality, at the end we minimize the back parts with a bluish-green glaze. The front part is done in yellow, partly glazed, partly opaque.
- With lightly tinted opaque white (in the background color), we now loosen the sculpture so it won't appear so massive. We apply partially soft light to the trunk and continue to texture its round shape.

Mediterranean pines are typical of Tuscany's vegetation. Countless landscape paintings show the pines' characteristic umbrella-crown. To paint a group of pines as in figure 67 (page 49), we first finish the background and trace the pencil underdrawing onto it. We start the painting with trunk and branches near the crown. The colors move from light to shaded and are best applied with two colors on one brush (figure 73). We cannot leave anything to chance with these unique, tall, denuded trees and their broken-off limbs. The pencil underdrawing should show the exact angle of the rising trunk and its relation to the other trunks. In the upper part, the branches extend widely. We can hardly follow a structural analysis. Painting from memory does not bring great results: we need nature photos and sketches. Whether the viewer can identify the pine is not important. The pines should make the painting come alive.

For the crowns, we start with a bluish pale olive green. We dab it on dry with a frayed brush (figure 74). The cool green makes these areas recede if we have painted the front branches with softer, warmer, yellowish greens. We now add slim branches in between the green shapes.

In figure 75 we use green mixed with white. This makes it feel cooler. The sunshine reflections seem stronger here; yellowish greens show more of the body color. The interplay of white with the countless varieties of yellow and bluish greens gives the crowns strong three-dimensionality and suggests a luminous sun. The easy, open brush flow allows parts of the sky to shine through. The crowns appear lively, as if swaying in the wind. This depiction of pines proves that painting is not a variation of photorealism. We create new moods by painting. They are similar to our impressions when we look at nature. The painter does not have to reproduce the natural image in microscopic detail.

We paint olive groves this way too (figure 76 shows the template). First we paint the background. Then we sketch the pencil underdrawing with chalk and paint the trunks in their three-dimensionality (figure 77). We follow with cool, then brighter, warmer greens. The olives have a silvery cool base tone. We can loosen up the trees' shape with opaque background and paint in areas where the leaves are too dense (figure 78). We set reflecting lights with brightest light green,

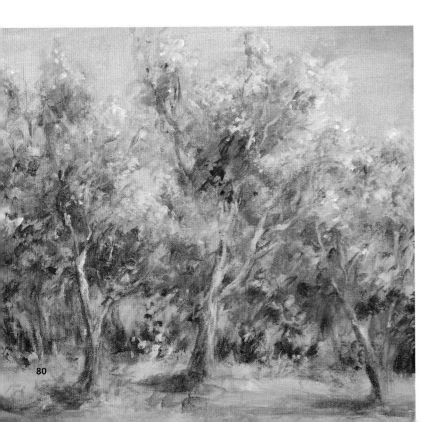

80

Tree crowns

especially on the side facing the sun (figure 79). With the shadow sprinkled onto the ground and abundant silvery reflections, the olive grove takes on an impressionistic feeling (figure 80).

The cool olive trees and the warm-colored foreground make the painting appealing. Its contoured disquiet, so rich in contrast, demands to see trees in front of a calm field portrayed in large, two-dimensional coloring.

We introduce an alternative design to figure 55 (page 51) in figure 81. Instead of complex faux architecture, the mural pictures a generous window with columns (matching the real windows of the house) through which we look into the tree tops of a forest. The viewer's position on the staircase is determined by the eye level on which the perspective construction of the window elements is based. This makes sense because from the real landing the viewer can see the painting most intensely. The viewer's movement has to be considered. The viewer constantly changes position and is close to the painting. The tree motif is free of perspective vanishing point. Depth of field is gained by color perspective and differentiating several levels. The depth effect is intact when the viewer moves alongside the painting. The composition's special charm is the invisible natural horizon. The painting suggests that the viewer is high above the earth, as he or she truly is on a staircase.

The design includes painted latticework (compare figure 55), an additional window in the upper area of the front wall, and painting of the remaining wall space (not seen in figure 81).

The sketched window image is the preferred solution for the project. Before execution we need to consider the following:

- The yellow fall colors of the leaves give the painting a seasonal mood. This trompe l'oeil painting no longer fits atmospherically into other seasons.
- We desire vegetation than more Mediterranean and Italian in feeling.
- The distribution of tree tops in front of the sky is too regular. The trees all appear at the same distance; the depth effect is limited.
- The regular distribution of leaves is not exciting. The painting holds our attention only for a short time.

A painting of 86 square feet (8 m²), consisting mostly of treetops, needs to be well thought out. We need to find characteristic trees shapes and put them in an exciting relationship to one another. The perspective depiction of the window frame was accomplished with a 3D computer program. We might want to visualize more of the design via computer. We select trees from our extensive photo collection of Mediterranean pines taken during various trips to Italy. We isolate the chosen trees from the background. In Photoshop each of these trees gets its own layer, so we can move and scale (change height) of any one independent of the others. Figure 82 shows the computer screen during work. The level with the window frame is in the foreground. We cut out the windows, so we can look out to the space beyond. The area with the tree at right, a Lebanon cedar, is not seen at the moment; we can see only the blue sky. We choose evergreens predominantly, so the paint-

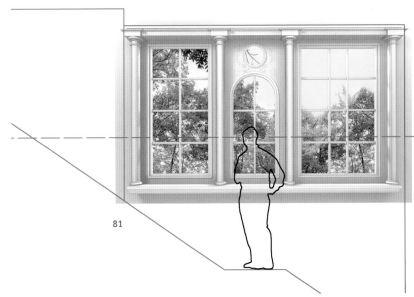

81

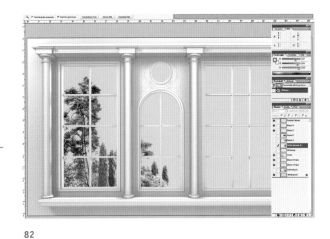

82

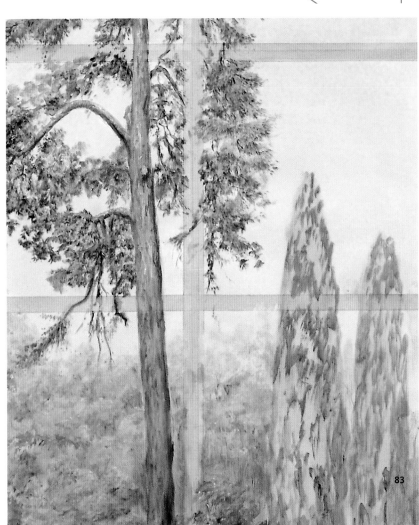

83

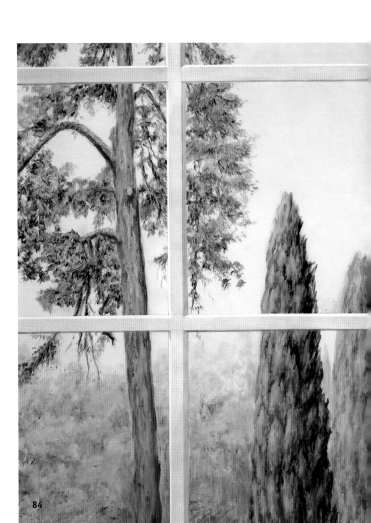

84

ing is independent from the seasons. Cypresses always make us think of Italy. We purposely vary the height and type of trees, making an interesting composition that we will enjoy looking at for a long time. Through the different height of the trees we suggest closeness and distance.

Different than in the computer design, the trees in the background are dabbed lightly and diffused in very light bluish green shades (figure 83). The background should disappear softly and seamlessly into the foggy sky. The sky is painted in progressive colors: below in hazy light blue, toward the top a more saturated blue. The cupola of the sky seems to arch expansively. Different from the light, atmospheric effect of the blue, the pine in the immediate foreground is contoured with strong contrasts and great detail. We feel that we can almost touch it. In the area below, strongly colored red, green, and yellow leaves push into the foreground. We can distinguish them clearly from the cooler background. The window muntins are taped at this point. Later they will play a role in the foreground, which adds a lot to the suggestive aerial effect and creates a link to the real room.

Both cypresses on the right are brought in from the background. In figure 84 we use an elevated perspective to paint trees standing closely one behind the other. The front tree is darker and more colorful and provides more contrast; the tree behind it is softer, more diffused. Figure 87 shows the canvas in the window panorama, painted in the studio to be mounted on the wall later.

The view of the Mediterranean park becomes elegant and cultivated through the cornice done in shades of gray. The Lebanon cedar on the right adds to this impression: the noble tree with its

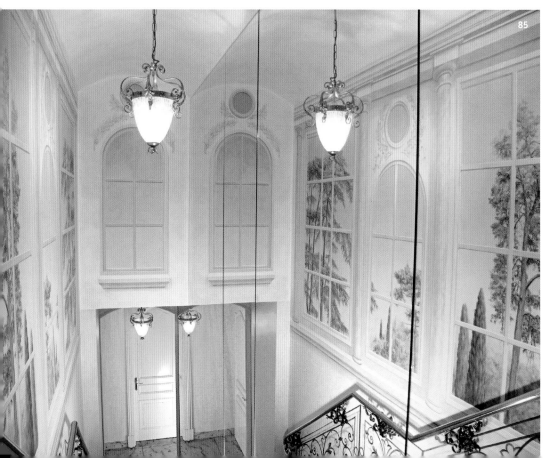

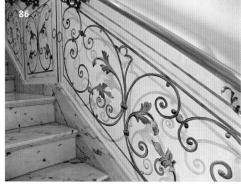

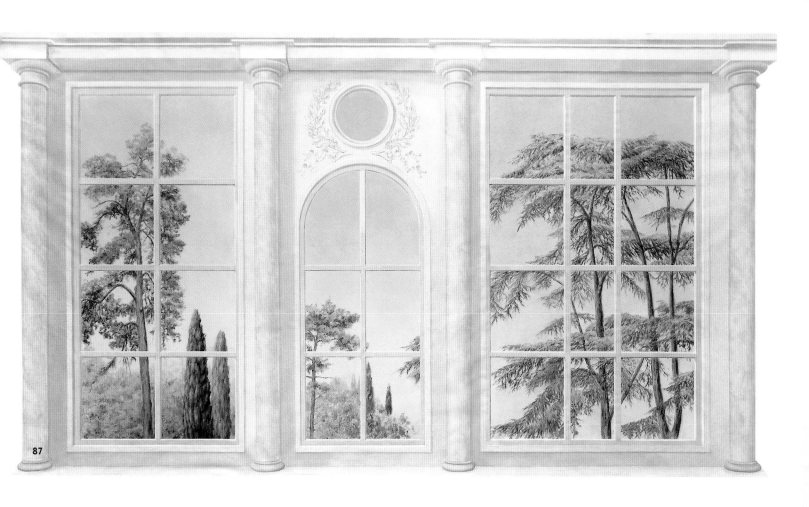

87

resin fragrance grows only in the Mediterranean in areas with mild winters, predominantly in large gardens and parks.

After mounting the canvas in the staircase, we paint the missing parts of the upper cornice and the profiled window sill directly on the primed wall, also the decorative iron fence that resembles real ornamental lattices. Its concisely painted cast shadow separates three-dimensionally from the wall and floats a few inches in front of it (figure 86). The latticework, marble columns, and cornice give the impression of being in front of the real space; the trees in the park appear behind them. This cleverly designed double illusion is maximized by a mirrored wall on the opposite side. We achieve a grandiose effect well integrated into the construction, in a small staircase (figure 85).

The examples of the treetop panorama show that trompe l'oeil painting has to be most convincing in special rooms. We cannot work with clichés. We do not have to portray a "classic landscape." A view into a park can also be a view into the park's treetops.

Mediterranean Sea View

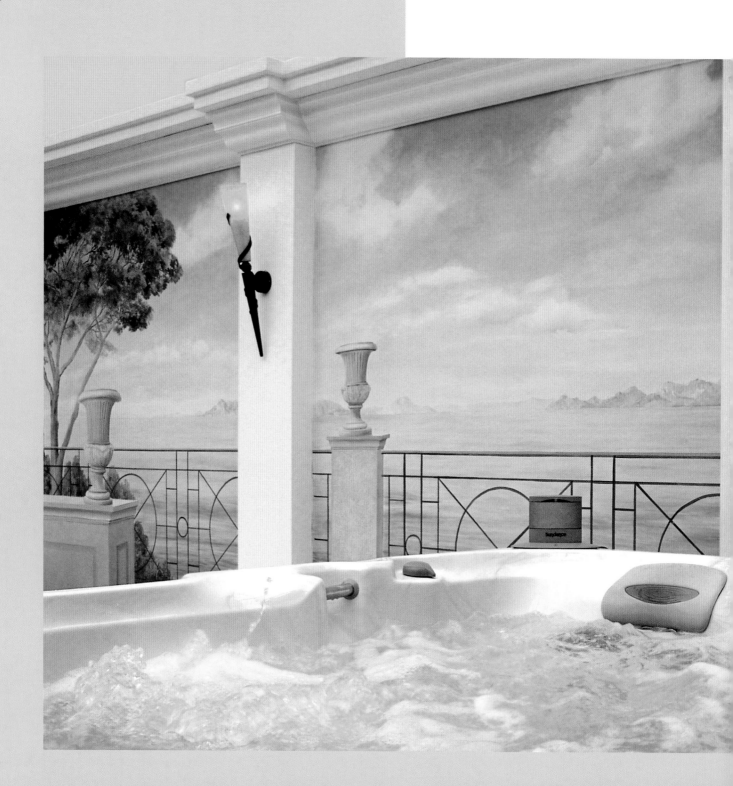

The layout

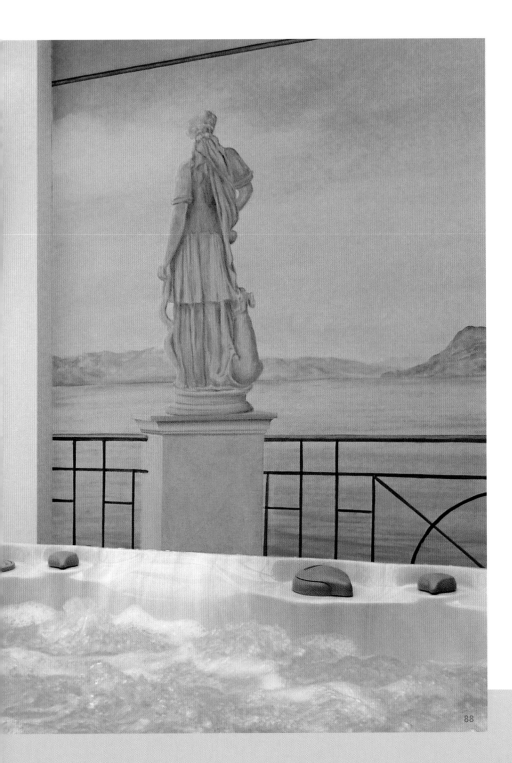

88

Next to Tuscany, lake vistas like the one of Lago Maggiore are favorite motifs for Italian landscape murals. Lago Maggiore is situated in the north of Italy, between the southern Alps and the Po Valley. It is 41 miles (60 km) long and 6.2 miles (10 km) wide. Such an immense lake area is of advantage in a panoramic wall painting: the blue of the lake can bring a larger expanse into the picture than the green of the landscape. Lake views are mostly portrayed from an elevated position, i.e., a villa's terrace or a mountain range. This gives the impression of an exclusive location. We chose this position for the project, which we show in this chapter from first sketch to finished product. We take liberties with our template. It is not important to exactly reproduce an actual landscape. Most important is the impression the viewer gets from the mural, the space it opens and the associations it evokes. In our example we use many elements common to classic Mediterranean motifs: southern vegetation, draperies, statues, architectural elements. This project gives you an understanding of the planning and step-by-step realization of large-size trompe l'oeil paintings with a Mediterranean flair (figure 88).

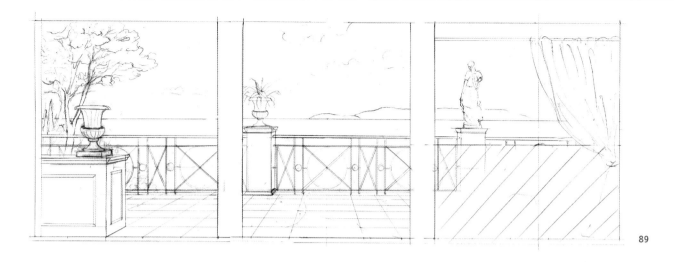

89

In laying out this painting, which is 6.5 yards (6 m) long and 7.2 feet (2.3 m) high (figure 89) the considerations are:

- The subject is a winter garden, which should gain a greater dimension of depth through the painting.
- The desired impression is an Italian ambiance.
- The water theme is important. There's a whirlpool in the room from which the painting will be seen.
- The painting needs to blend in and harmonize with the room's structural elements.
- The price should be reasonable.

In laying out the design we need to be aware that we are not installing photo wallpaper. Instead, we need to compose uniquely for each room. In the end the painting should be harmonious, unobtrusive, and integrated naturally. It should not try to draw our attention away from the room with special effects. In the layout every painted detail is inspired by the room and the task ahead. The hatched space in the lower right marks the place where the whirlpool will be situated, a short distance from the painting. We do not need to paint in here. To counterbalance the pool we add a small wall on the left side. Its color matches the whirlpool's planned casing.

A trisection of the painting is accomplished with two pilasters dividing the wall. We can complete the painting in three separate single parts in the studio. Later, we tape them onto the wall on-site. The painting does not end left and right with the corners of the room, so we need to create a transition from the wall space to the painted vista. This will be done with drapery. There is not much distance between the upper edge of the whirlpool and the painted horizon. To gain depth of field in the right-hand part of the painting, a statue reaching far above the horizon creates a contrast-rich foreground. The blue sky recedes. For compositional balance, we place a stone vase on the wall in the left part of the painting. In shape and color the vase matches an actual vase in the room. The same is true for the railing of the terrace: it accompanies the small staircase that leads into the room on the opposite side. The large glass windows of the winter garden inspired us to place an umbrella pine in the left corner. Its typical fanned crown is quintessential Italy. And now the drapery on the right side has a counterbalance. Colors and tile grid match the real floor, which is continued in the painting. The vase on the column in the middle section echoes the vase in the left-hand third of the painting. The vase motif, dominant in the foreground and small in the middle, heightens the room's perspective as defined by the tile.

Opening a room

We put the canvases on three large stretchers that we can move around freely. We can paint the lower parts using an easel to have a more comfortable working position. Each landscape is painted "back to front": first, we paint the sky (figure 90), glazed in many layers. We leave out white colors, the light areas. We start with the brightest color on the horizon. Higher up, we use darker, more saturated blues. The texturing of the clouds into light and shadowed side can be done in the first layer with soft gray shading.

With traces of ochre, we paint a light sunny shimmer onto the horizon. We might add ochre to the white clouds also. Figure 91 shows the sky painting after the third, but not last, glazing. Before finishing the sky, we have to add the painting's other elements. Fine tuning is only possible for the total image. Each element depends in its impression on the other elements.

We see this when we add the sea to the sky (figure 92). When we apply turquoise instead of white, the overall effect on the room is enormous. Depth is created because sky and sea are brightest at the horizon. The sunshine seems to shine into the picture from the horizon. The tile floor adds to the suggestive aerial effect.

The gaps in the tile floor (figure 93) are smaller and brighter in back, and wider and darker in front. This makes the perspective convincing. When we glaze the gaps white with a bristle brush, we need to pay attention that we do not create too much contrast.

Illusionistic mural painting should not appear graphically exaggerated. We glaze the entire floor, beginning in the back with a bright shade, and then glaze more strongly in the front in the color of the actual floor. We mix in some white to achieve changing light reflections. The original tile grid or its exact colors are needed as a reference while we paint.

Light plays an important role when we paint the railing (figure 94). All the upper sides should be

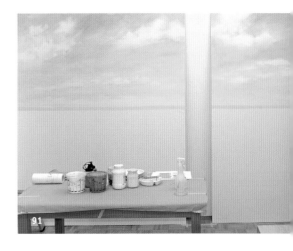

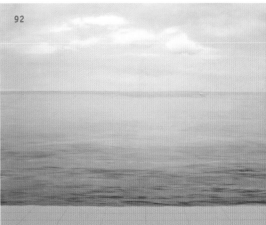

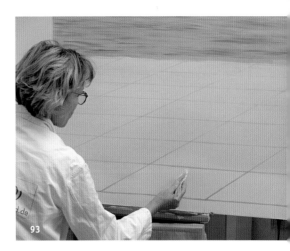

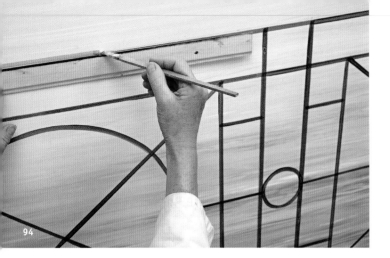

94

95

The umbrella pine

The umbrella pine (figures 96 and 88, left) is created following the steps outlined on pages 52 and following. The first drawing of trunk and main limbs is done freehand or with the photo traced via overhead projector or grid. Then we dot in the crown's green shades dryly with a frayed brush. The side of the crown facing away from the viewer is done in light blue-green; all the undersides are darker. The parts of the crown facing the viewer are stronger-colored than the ones farther behind. Making the upper branches become yellow-green and brighter, we create three-dimensionality. The crown is done in a continuous refining process. We follow the principle of darkening the undersides (figure 97). The parts further away become cooler, the upper and foreground parts brighter and warmer.

Three-dimensionality is emphasized by giving the limbs a light and a shady side (figure 98). We need to pay attention to this texturing from the start. We can use light and dark brown on the same brush or apply both colors side by side, then paint them wet-into-wet.

The effect is realistic when the branches are variously in front of the green and covered with the green. The most interesting and decorative effect for the intertwined limbs is created when the blue sky shines through them.

This underlines the three-dimensionality of the tree, which becomes a distinct foreground to the sky.

The fine-tuning of the crown is done with light

drawn with a bright edge. The top of the railing is given a light gray finish. The painting of the railing in our example is—according to the budget—very stylized. A pencil underdrawing for the three-dimensional cornice, onto which the lattice is fastened, is done on parchment paper, and

transferred to the wall with graphite paper. The translucent paper allows the exact positioning of the underdrawing. We can also color the back side of the paper with chalk and then use pencil to trace it. Always use chalk pencils similar to the color you will paint in later.

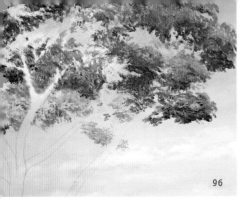

96

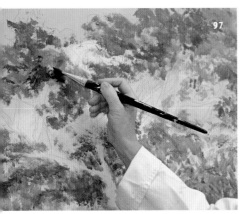

97

colors. As light intensifies, it adds considerable volume. Figure 100 shows the countless nuances of green that are created when we work out the crown this way, successively. The interplay of light and shadow, the design rich in shapes and colors give the tree its charm. The painting will delight for years to come.

The finished crown (see figure 117, page 72) becomes convincing through

- its open shape that allows the sky to shine through
- no outlines, only lively cool and warm, dark and light nuances of green next to and above each other
- clear separation of the front and back parts of the umbrella
- the intertwined limbs and the shimmering of white light reflections
- a concisely textured trunk in the sunshine.

The tree is now an attractive counterpart of the drapery at the other end of the painting. Tree and drapery complement each other in style and color. As elements in the composition, they have exactly the same weight.

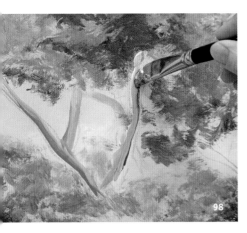

98

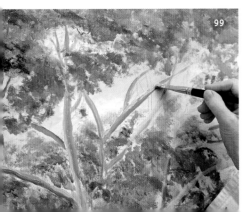

99

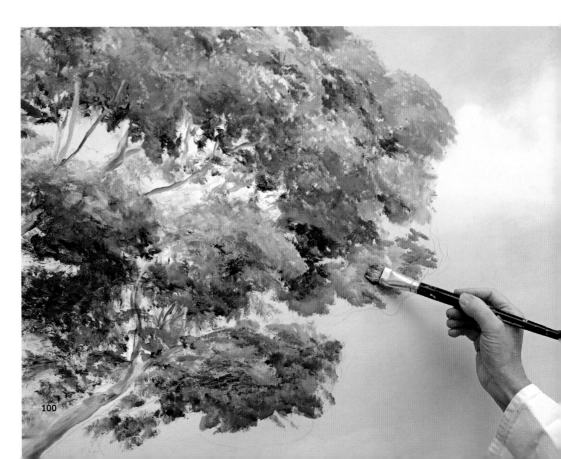

100

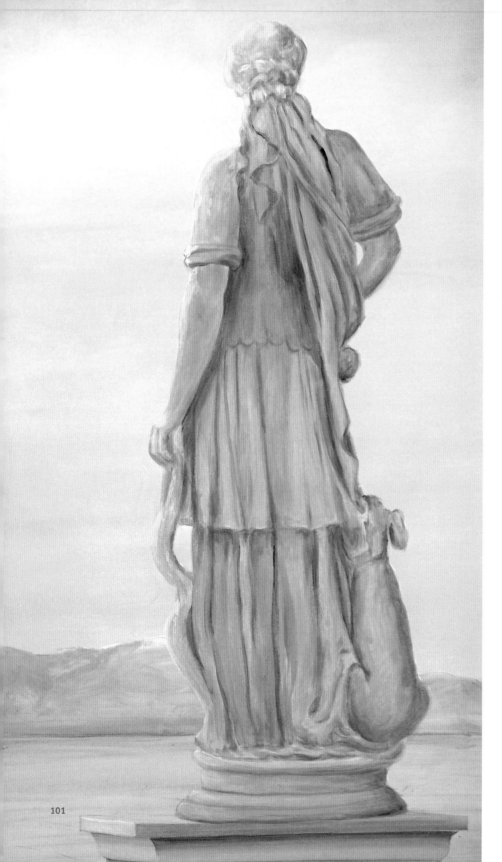

101

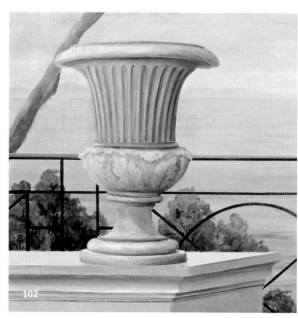

102

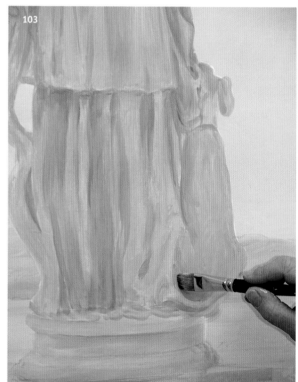

103

Sculpture

To portray the stone sculptures of urn and statue (figure 101 and 102) we prime each object in sandstone color. The brushstroke follows the three-dimensional form. In this way we can distribute light and dark from the beginning according to the relationship of light and shadow. Note that the urn's foot is below the horizon and its opening above the horizon, so we look up at the foot and down from the wreath above. We trace the leaf ornament with chalk paper onto the underpainting.

The statue's expression is most important. Viewers project emotional states onto the human figure even in a stone sculpture, so we try to capture these emotional states in our painting. The human figure is more than a decorative object. We cannot use one statue like a cliché for all sorts of paintings. The mood of the statue must harmonize with the mood of the painting. It takes skill to find its proper size. This statue of Diana is unusual because it is shown from behind. She and her dog seem to glance over the lake. This gives the painting calm and a hint of wanderlust.

We consider light and shadow from the first brushstroke of the underpainting. A good photo template, studied over and over is essential so we make no mistakes in posture and proportions.

Gradually we deepen the three-dimensionality by applying dark tones (figure 103). The light gray underpainting, partially visible until the last stage, creates a soft, light, overall impression. If we had not decided on a stylized version, the painting in figure 101 could have been refined with the porosity of stone, a cover of lichen, wear and traces of weathering.

Between sky and water we add the alpine mountain chain (figure 104); mixing all the mountain colors with sky blue so that the mountains seem to disappear in a blue haze and the painted mountain tops have a light and shady side. They remain blurred because these mountaintops are far away. The very bluish, bright mountains are farthest away; several green and brownish hills are closer. At the foot of the mountain we draw a shady line. The viewer will interpret it as the dark strip of the shore (figure 105).

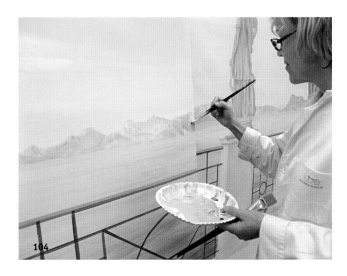

104

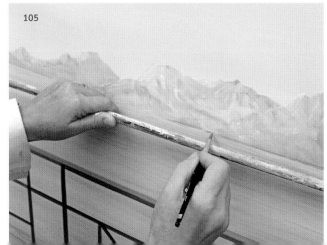

105

Drapery

We need to have sketches for the individual elements and to practice before we execute these sketches. The purpose of the curtain in figure 106 is to practice our dexterity in texturizing the dark and light three-dimensional folds. To get a flowing, natural representation, these themes have to be practiced as a musician practices etudes. Photos are an indispensable aid. Create a collection of templates for draperies over time. The decoratively draped, partially illuminated, iridescent silk fabric in figure 107 convinces because of its sculpted character, but silk might be overly sophisticated for the painting.

The drapery on the right side will be glazed. We need a brilliant white underpainting that follows the outline of the pencil underdrawing. The underdrawing can be masked with tape for a clean underpainting (figure 108).

The priming color, a radiant orange with a little vermilion, harmonizes with the color of the beams in the winter garden. Because of the glazing, this intense color does obtrude. As the first step of the work, we can apply the folds vaguely (figure 109).

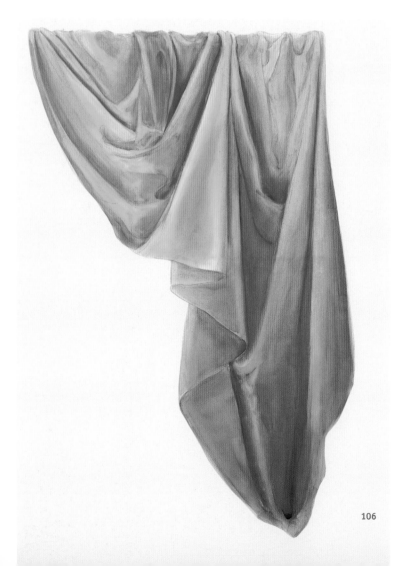

106

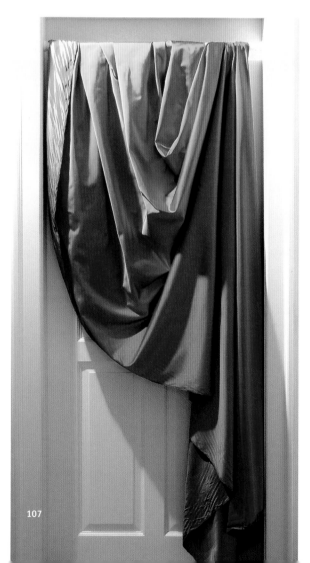

107

108

109

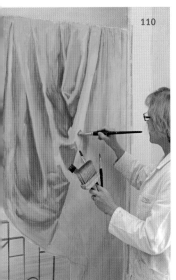

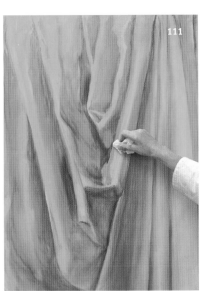

110

111

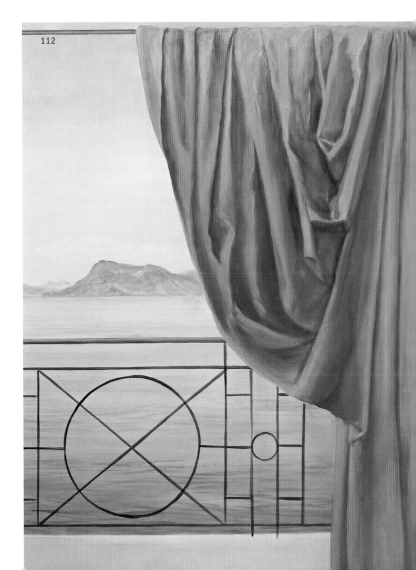

112

Once the prime coat is dry, we trace the structure of the folds with chalk. We achieve three-dimensionality mostly with dark reds. It is not simply a graying of the base color, but a mixture with brown, burnt sienna, carmine, and vermilion (figure 110). It is important to use several layers of glaze, especially for the dark shades. The colors keep their force and vitality without appearing

Hard shadows

113 a

Shadow construction

P Cast shadow point
S Source of light (sun)
h Horizon
a Plane of projection
S Vanishing point of the sun on h
P Vanishing point to be projected on a

Notes

1. Most of the time we do not see the sun directly in murals. Set its position (outside the painting)
2. Calculate to P the vanishing point P and to the vanishing point S
3. Draw line S – P.
4. Draw line S – P
5. P´ is the intersection of both lines

heavy. Wonderfully soft transitions are possible, especially when we use brushes of different width at the same time. We apply the lighter color with one brush; the darker is set next to it with another brush. Now we can blend colors wet-into-wet. We use an additive we make (Benadium) so the colors won't dry immediately and use an emulsifier to smooth the brushstrokes.

To lighten, we mix the prime color with pastel yellow, and then apply it half opaque, half transparent. If we mix only white into the primer or glaze it with transparent white to achieve lightening, a cool color or murky haze would result. Even when we apply lights with a warm pastel tone, we lose the subtle effect of the glazing and its illuminating power. Many parts that appear elevated are created by dark glazing of the primer. We start at the border, and then use a piece of fabric to rub it free in the middle. Toward the border we create shades as soft transitions. In the middle, the prime color seems to shine out and arc forward (figure 111). The vital red creates a fiery foreground effect. Other elements of the painting like the statue are pushed into the background. The red compensates with its warmth for the coolness of the entire composition.

We can intensify the effect on the room when the painting contains concise hard shadows. The imaginary sun shines from the sea in direction of the viewer. Therefore the shadows of railing and vases have to fall onto the painted tile floor. We can construct the actual direction of the shadow on the wall, because the location of the sun is above the ceiling and its vanishing point is often far outside the painting. The shadow has to be constructed at the drawing board or, as in figure 114, with a computer graphics program. Later it will be transferred via projection, grid, or tracing. We often overlook that for hard shadows on a perspective floor, shadows that are "in reality" projected parallel to the floor have to be in proper perspective in the painting. For the painting in our example, this means the following: The shadow of the left railing falls steeply to the front; the shadow of the right railing falls wide to the side. The hard shadow of the column is not parallel at all: it becomes wider in the front. Figure 113 illustrates the principle of how to construct the shadow:

- Locate the position of the imaginary sun in the painting (i.e., outside the painting).
- Construct the vanishing point of the sun on the horizon as well as
- the vanishing point of the object whose shadow projection needs to be located (on ground).
- Connect the sun with a cast shadow point at a grade and
- connect both vanishing points with a line.

- The intersection of both lines marks the place of the projected shadow on the ground.
- To project an entire railing, calculate the shadow's position for its major points and add the railing shapes in between.

The finished construction can be transferred one-to-one with a template for tracing. We recommend graphite paper or using chalk to color the back side of the template.

A shadow is not permanent; its appearance is fleeting. Therefore it should be applied transparently over

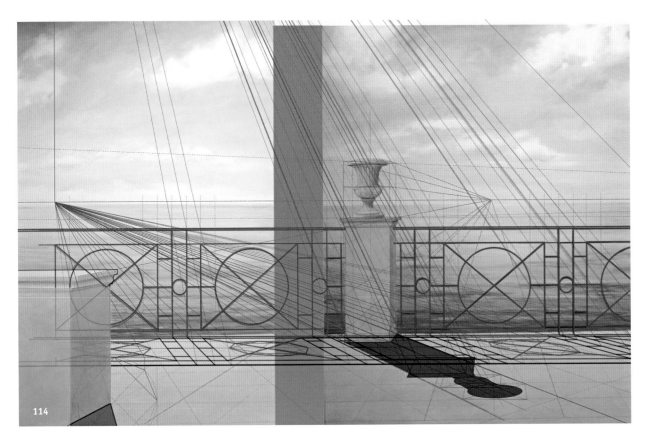

114

the finished painting using not black, but Payne's gray and a little violet as needed (figure 115). Sensitively coordinated colors integrate the shadow into the painting without looking out of place. If we succeed, the sun seems to break through from behind the clouds. It even shines onto the painter!

The shadow graphically animates the modestly structured foreground. We create an additional illusion of space with clear lines for the shadow in the front part, and soft diffused mountains in the back part of the painting.

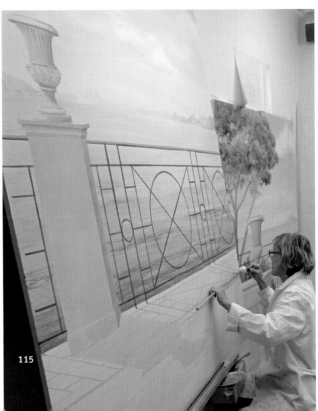

115

The color palette

After mounting all three canvases on-site (figure 117), we realize how important color coordination is. The painting should not just portray objects; it should become a painted mood. Figure 118 shows the most important basic colors we used. The painting has countless more shades gained by mixing these colors with each other. The painting motifs and colors have been well planned to harmonize with the winter garden.

We can spend many more hours to perfect the painting (see figure 116). Decide in the planning stage how much detail you will use. Otherwise you might spend too much time with minute details and loose sight of the overall impression.

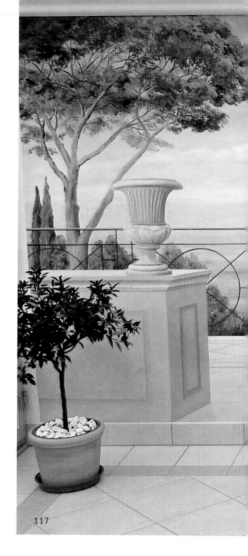

117

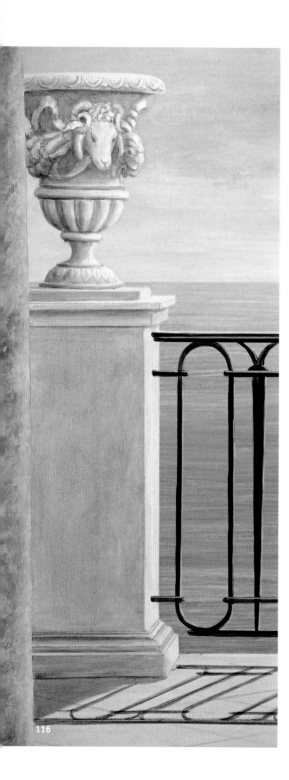

116

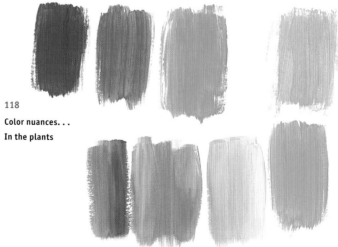

118

Color nuances...
In the plants

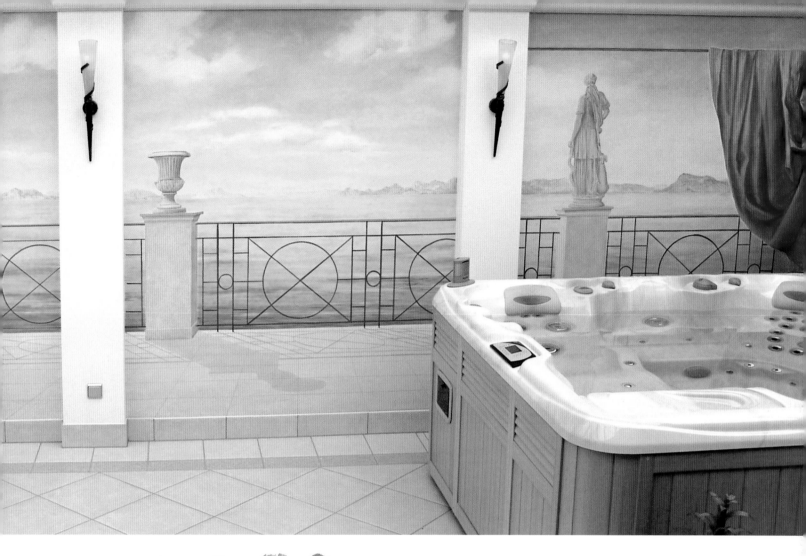

In the water

On the floor

In the drapery

In the shadows

5 Architecture Through the Centuries

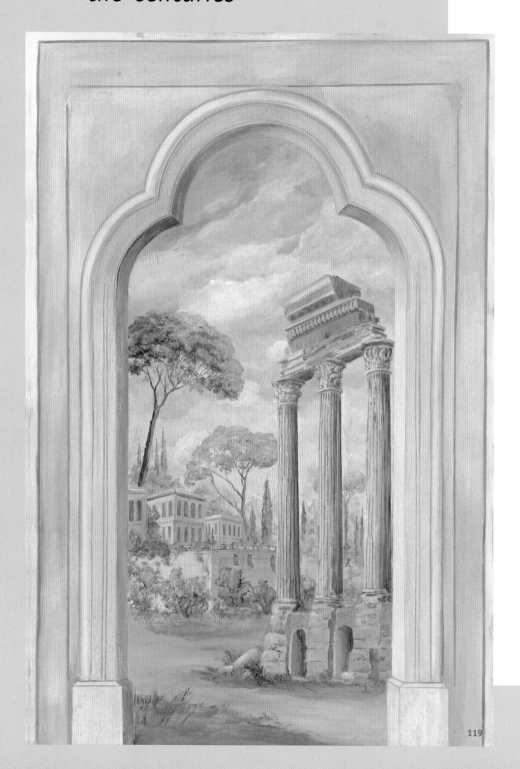

There are two varieties of architectural representation in trompe l'oeil murals: faux architecture and buildings depicted within a painted stage set. Figure 131, pages 82–83, illustrates the successful application of both. Through faux architecture the underpainting—the wall space of the future painting—becomes the architectural frame for an imaginary look into the distance (elements of grisaille are used to imitate materials). Figure 131 depicts arcade arches that reveal a view of the Grand Canal in Venice. There are three levels in the painting. The first shows the arcade arches in proper perspective, the second the diminished rear columns. The third level is found beyond the water. Here the architecture no longer connects to a real room, but is part of a stage set.

In trompe l'oeil painting, architectural motifs are almost always those of centuries ago. Because of their distance in time from the present, they can seem ideal and ethereal. In their reduced form our contemporary buildings do not invite us to look at them. Richard Meier's Ara-Pacis Museum (at left in figure 17, page 18), with its unadorned white walls, seems like a foreign object in the center of Rome. This museum will not become a favorite motif in mural painting.

How different the ancient ruins: deteriorated over thousands of years, they have become more and more a part of the landscape. They do not seem

strange in their surroundings. Instead, they give meaning to their surroundings.

The "fresco" (figures 119 and 120) shows three Corinthian columns from the temple of Dioscuros in the Roman Forum, built in the fifth century BCE. We delight in the panel because of its two-thousand-year-old motif. It shows the current state of the temple fragment one can still visit in Rome today and turns it into an object of its own illusionism. Executed in fresco colors, stretched on an especially heavy frame, it looks like a heavy, massive slab. With its sandy plaster structure, its cracks and abrasions, it seems like a fresco from the past. Placed in a green landscape—without tourists or barriers—the temple fragment painting seems like a document from centuries ago. The painted architectural frame creates the necessary distance so the viewer can look at this double stage set. At the same time the frame connects to the walls of the room where the painting hangs.

Similar elements are used in the "fresco" painting shown in figures 121 to 123. It depicts an even older monument, the Arch of Hadrian in Athens. The motif is taken from a 1762 watercolor showing the condition of the monument in the eighteenth century. We place it in a picturesque environment so the viewercan imagine walking through the painted archway. Technically the painting, like any other landscape, is constructed

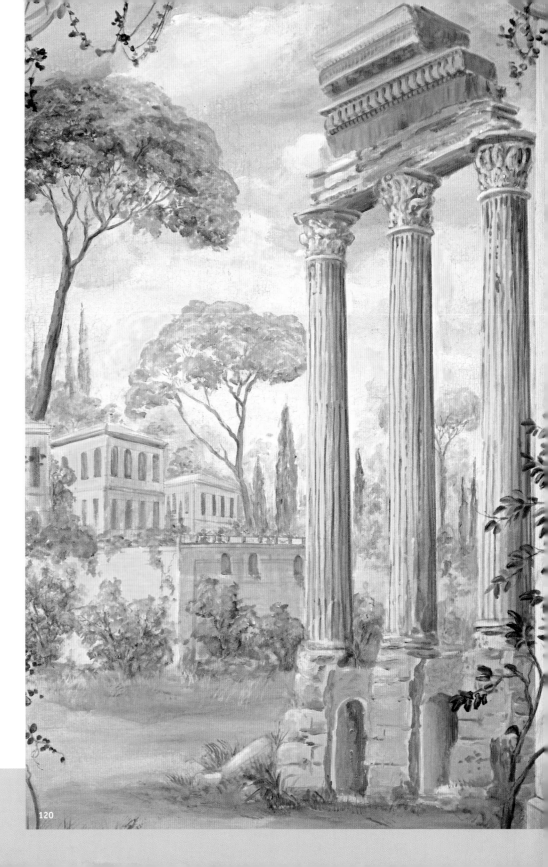

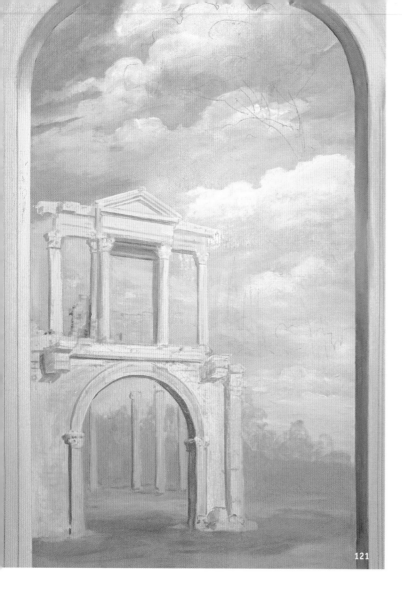

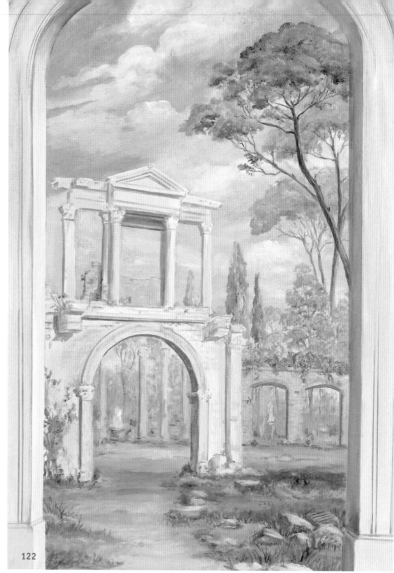

121

122

from the background. We tape the archway first. Then we paint the sky. In the lower part of the painting the sky changes into a diffused grisaille landscape underpainting. Instead of using sky blue, the predominant choice in illusionistic sky paintings, we use Payne's gray mixed with ultramarine, plus "baroque" cloud coloring with Naples yellow and English red. The colors are extremely flat because we want to create the impression of a limestone fresco. To achieve this we mix gesso, normally used to prime canvases, with acrylic colors. The pasty, thickened acrylic paints are unsurpassed in their flatness. They make it easier to paint opaquely *a la prima*. We can also mix colors with champagne chalk for a fabric-flat and limelike appearance.

In figure 121 you can see the pencil underdrawing of the trees to be transferred to the finished sky (figure 122).

We paint ornaments on the archway. Framing the depicted scene, the ornaments create a link to the

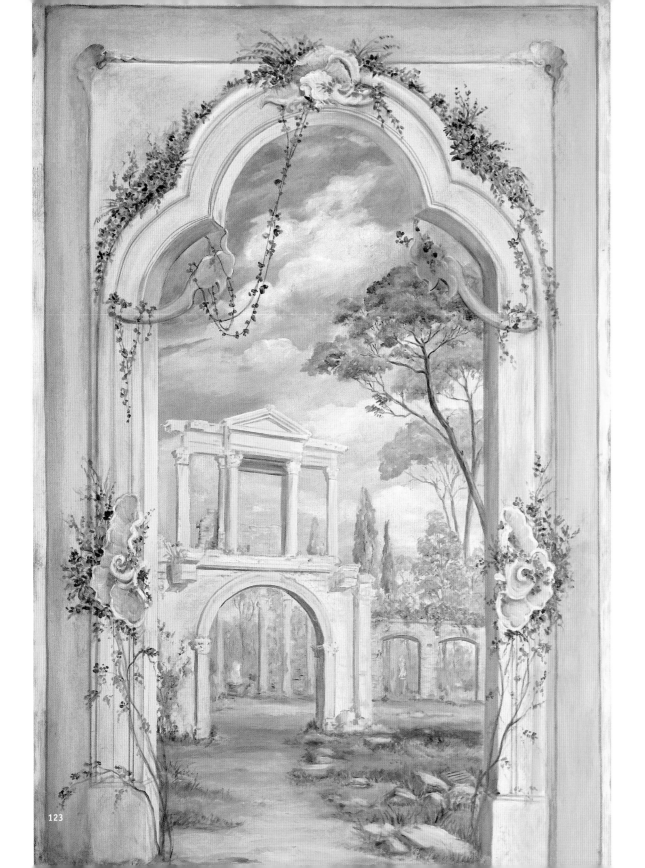

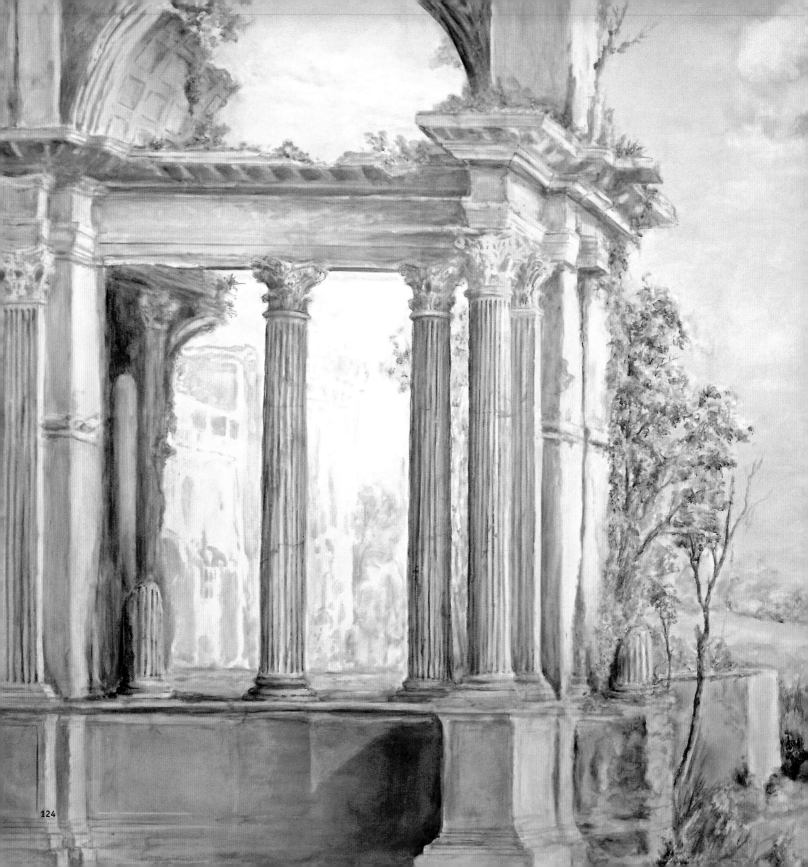

124

decorative elements of the room where the painting will be hung (figure 123).

The panel shown in figure 124 was done in a similar style to make it appear more ancient. We took elements from a painting of ruins by Pierre Patel I (1605–76) and painted them in acrylic. We omitted the painted frame because the work was done to exact specification to fit into an alcove. The painting now presents a view into the past through the faux window opening. The work remains unobtrusive in the background because of the grayed atmospheric color. First—and this is special—it has been applied as almost colorless grisaille. The colors, added in the end, lend a glazed complexion to the grisaille. We carefully "stack" them onto the light–dark painting. This way, the painting seems old, historically grayed, the architecture depiction unreachable, dreamy, lacking three-dimensional precision.

The first painting layer of the temple landscape in the "romantic" style (figure 126, see also pages 2–3) is shown in figure 125. This large landscape painting was created in the studio. As is common in landscape painting, we develop the painting from the horizon to the foreground. At this stage the architecture of the small temple is masked and left white.

125

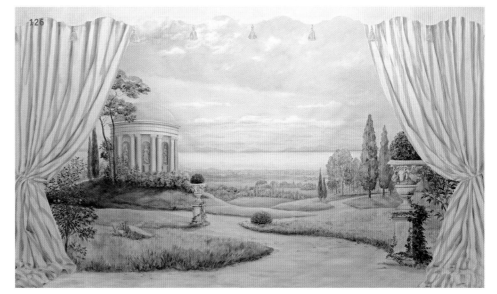

126

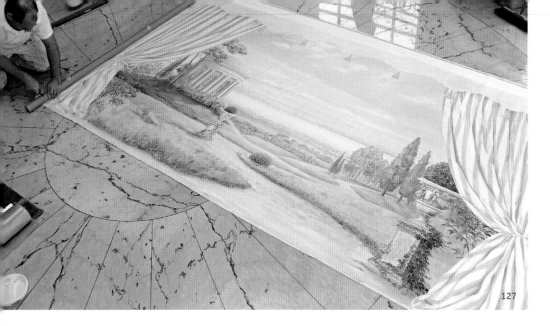

The temple belongs to the landscape; it represents a special place. The statues, the enchanted park, and the meandering paths, the groups of trees and plant containers produce a refined nature painting. Nature and culture create a bridge to the elegant ambience of the future home of the painting. Once finished in the studio, the painting is masked professionally on-site (figure 127). The coloring is not as in nature, but brighter, less saturated. The portrayed scene creates a dreamy mood. We have not used a historically recognizable place or a specific action, so the viewer's imagination can wander. The viewer can walk into the painting as though it were an unfinished story (figure 129); the composition makes it easy to "enter." The viewer can almost take a step from the marble floor into the landscape; the path leads step-by-step deeper into the painting. The viewer can turn left to visit the temple, go straight into the valley up to the small forest, or follow the path on the right.

The landscape scene is not framed by painted architecture but by painted drapes that are drawn back. These drapes have a similar color to the room's glazed walls. This way, the transition between real walls and painted landscape is plausible (figure 128). A real veranda can be framed in

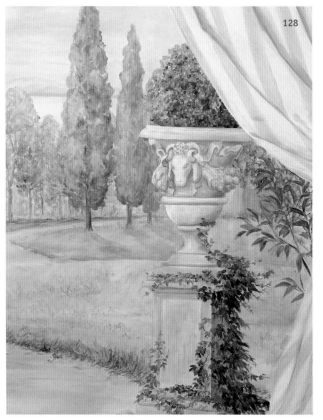

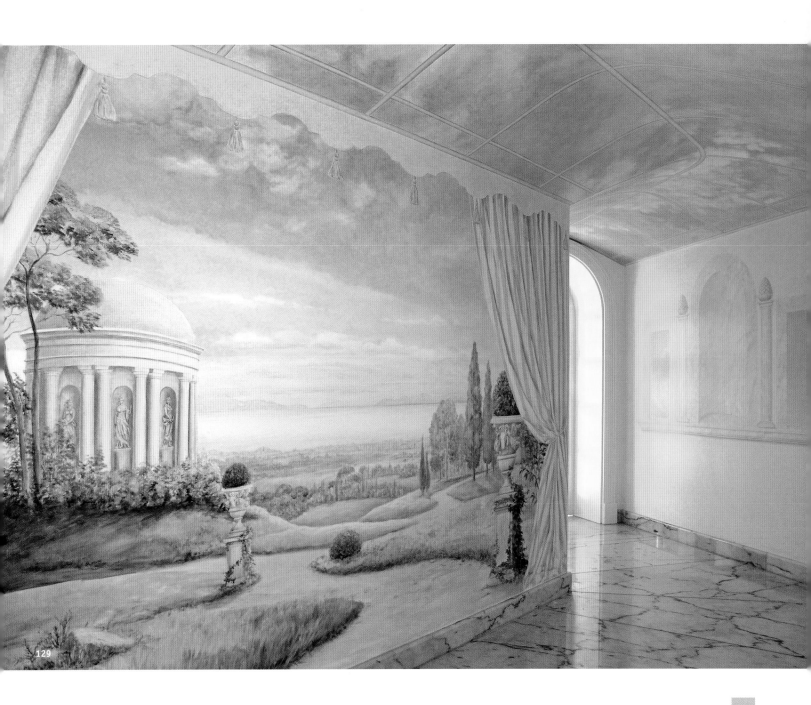

129

a similar way with real drapes. The slightly arched ceiling and the transitional space between ceiling and wall are expertly integrated. There is a pelmet with decorative tassels in the upper end of the mural. Below and above we see the sky. We no longer recognize the corner of the room. The ceiling changes into the ceiling of the winter garden. The filigree metal bars on the ceiling (as figure level 1) combine the sky with the blue room elements in a convincing way.

We have grandly enlarged a small room lacking in natural light and added a new dimension. The grisaille painting on the wall seen at right is done with restraint. The main painting should take center stage.

Could illusionistic architectural representation do without the palaces of Venice? Venice is a unique phenomenon in architectural and cultural history as well as mural painting. Many of the large palaces on the Grand Canal were built in the fifteenth century, some even earlier. What the visitor sees today is five hundred to six hundred years old, dating from the Gothic and the Renaissance periods. The palaces are still used and lived in today. Millions of people come to Venice every year to see this grand open-air museum that is truly a lived in, lively environment. We move as if in a theater setting and hardly believe what we see. These unforgettable impressions can live on in a mural at home. That is why Venetian motifs are in high demand in illusionistic paintings.

The heavy linen drapes covering the arcades of the centuries old coffee houses at Venice's Piazza San Marco (see figures 9 and 14, page 11) are in the foreground of the project, shown in its beginning state in figure 130. The opening does not lead us into a dark restaurant. We open the building from the back to reveal the view of the Grand Canal. The viewer now is across from the fifteenth-century Palazzo Contarini.

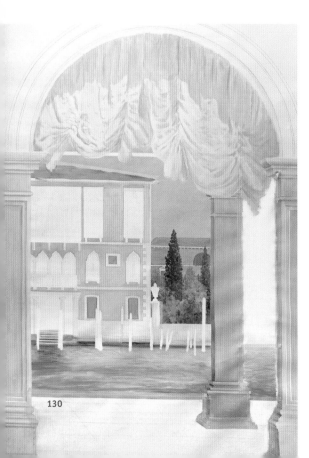

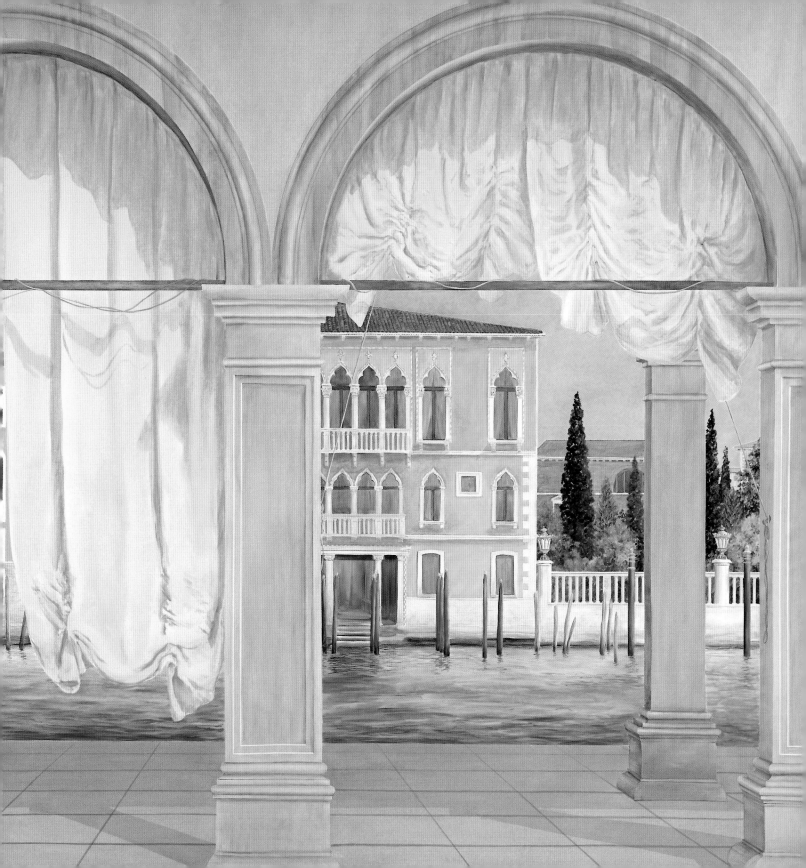

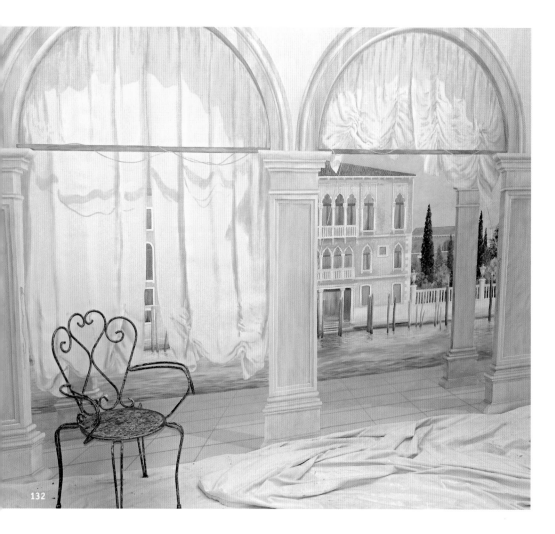

at the column shafts and arches, demand exact contouring and three-dimensional texturing of all light–dark transitions with the help of a mahl stick. The painting, although embellished, is done in an objective, true-to-nature style. It never becomes a cliché. No gondolier rows by. No one wearing a Venetian carnival mask walks into the picture. We want to look at a painting often and for a long time. Therefore we cannot use clichés. The painting itself needs to convince us, e.g., with meticulously painted drapery, the precise play of shadows, and the entire composition's highly refined color palette. Figure 132 illustrates what we said earlier about faux architecture: the painted arcades turn the real walls into fictitious architecture bridging the real "in front" and the illusionistic "behind." The first level of the painting shows proportions taken from the viewer's real area of action. In reality, the arcades are more than 13 feet (4m) high; in the painting they are 8.2 feet (2.5m) high. Nevertheless you might feel you can walk through them. We achieve this through a floor constructed in perspective. The aligned gaps and the capital have a suggestive effect on the room which continues on the other side of the canal with the help of differentiated levels. It is very important that the garden starts at the right side of the palace.

Different trees and bushes stand in front of each other or one after another. In the back, they border a diminutive building.

The room effect gained by perspective architectural representation is stronger and more elaborate than in pure representation of nature. We can

The artists took the liberty of letting the palace border the garden of Saint Vidal Church.

Do not underestimate the time it takes to paint detailed architecture! Usually, the sky areas take up most of the room in murals. They are painted quickly. In figure 131 the sky takes up only five percent. The foreground, though not spectacular, needs a lot of work. Nine column bases or capitals, including three-dimensional profiles

deal freely with rows of trees that disappear into the distance. We can vary the space and height of the trees. We cannot take this liberty with a row of columns done in correct perspective. Here the proportions have to be accurate!

Painted balustrades often have the same function as the arcade arch that connects the real room with the imaginary room in "figure level 1" convincingly. Figure 134 (depicting the promenade of the Isola di S. Elena) can be a template for our painted balustrades. The architectural painting on the walls of the indoor pool in figure 133 enlarges the room illusionistically. We achieve this by re-interpreting "figure level 1" in proper perspective from the corners of the room and the transitional space of wall and floor.

For the painted palace we cannot interpret the wall space as the building's facade. The height proportions are not believable. Everything painted onto the wall is as if it belonged there in reality should be done on a scale of one-to-one or slightly reduced.

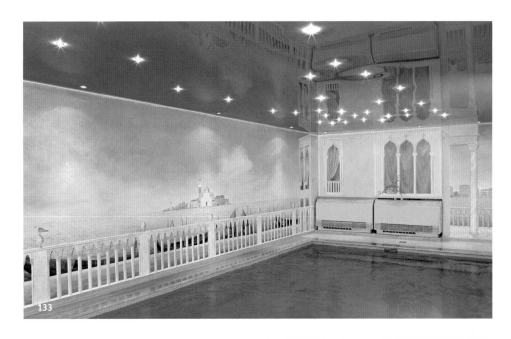

133

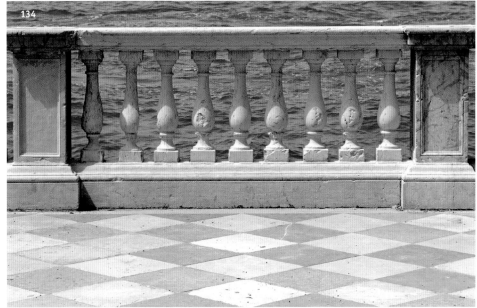

134

135

Characteristic of many Venetian palaces is the Gothic tracery of their windows. We use it here for the first time for a private home, not a religious building. No painter or photographer can resist the breathtakingly lively mix of five-hundred-year-old stone masonry with contemporary wooden shutters, flower boxes, blinds, and awnings. The painted windows in their three-dimensional mounting are an excellent subject for trompe l'oeil painting. As freely movable panels they are—even without a panoramic painting of the entire wall—attractive decorative elements with a trompe l'oeil character (figure 136 and 137). We can apply the motif shown in figure 135 in a similar way. Figure 139 shows a motif exceptionally well suited for a landscape format above a credenza or a headboard: the upper floor of the Ca'd'Oro (dating from the first part of the fifteenth century).

We might use photos of Palazzo Bernardo, finished in 1442 (figure 140) and Palazzo Pisani Moretta, fifteenth century (figure 141) as inspiring templates for painting in the style of figures 131 or 133. A panoramic view from the Grand Canal with the Rialto bridge, enjoyed and painted for centuries, is shown in figure 138.

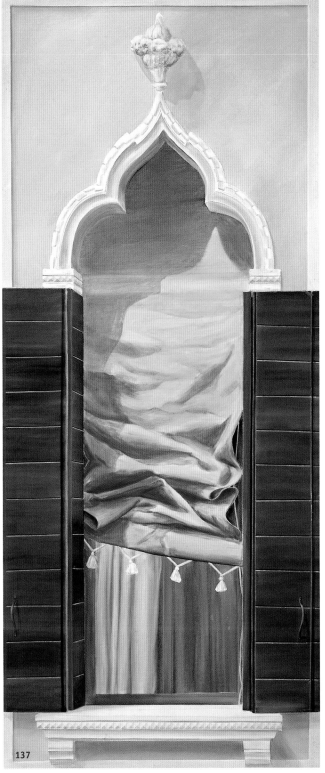

136

137

138

139

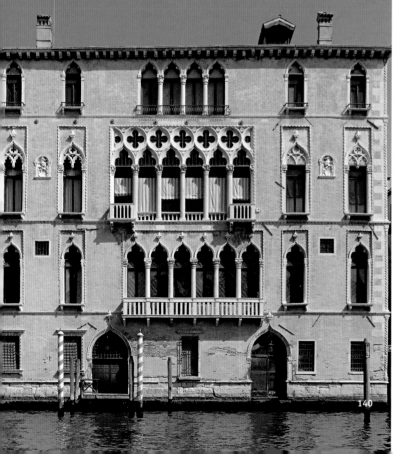

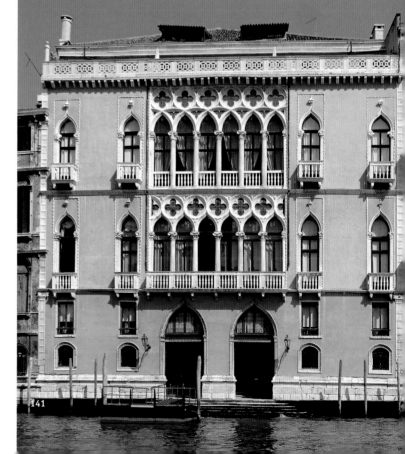

140

141

142

144

The painted Gothic and Renaissance windows of Venice undoubtedly reflect the time of their creation. Contemporary wooden shutters and colorful facades refer to a sun-drenched Mediterranean town. We do not have to stick to a particular style. Two photos of Roman facades (figure 142 and 43) start a window sequence unconcerned with illusionistic character. Paintings 144 to 146 are all about color, tone, the play of light and shadow flickering across the wall and window.

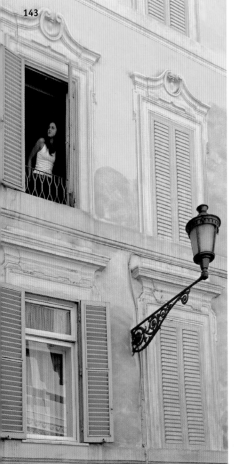

143

145

146

We use glazing exclusively to achieve transparency and lightness. We create a modern decoration in combination with glazed color panels showing a cloudy, delicate polychrome. It unites representational and abstract elements and brings the sunny warmth of Mediterranean facades into a cool business environment. (The project in figure 147, a design concept entitled "Mobile Color," developed by the authors, has been published extensively.) The painting is interesting because we cut the window shapes without considering the borders of the represented object. We freely combine these elements with the color panels. Somehow these might be real windows; at least they don't seem so unrealistic in their place.

Figure 150 is an example of an even freer way to combine the architectural template with the special conditions of the room where the painting will be hung. Trompe l'oeil paintings work mostly with a "reality bridge"—a painted frame for instance, in the form of an architectural element or drapery. In the case of figure 150 (which has been executed) and figure 148 and 149 (created as draft collages), the bridge is an abstract wall. A square "window hole" has been cut into the walls (they might be interpreted as a super-colossal, strong-colored photo mat). We see Italian monuments through the windows: the Coliseum, the Leaning Tower of Pisa, St. Peter's Basilica. We limit the view to a section of the upper part

147

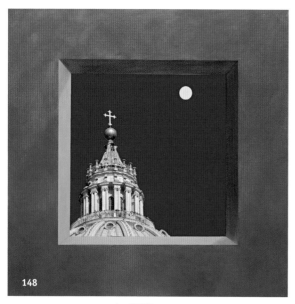

148

149

of the buildings. The viewer feels transported to the upper floors to experience the view this way. It does not matter that the perspective on which each building is based does not match the central perspective of the wall-breakthrough.

These paintings are not true trompe l'oeil paintings; they play with a trompe l'oeil character. The best way to portray world-known subjects is in to avoid clichés. Create an original interpretation that the viewer can better appreciates.

150

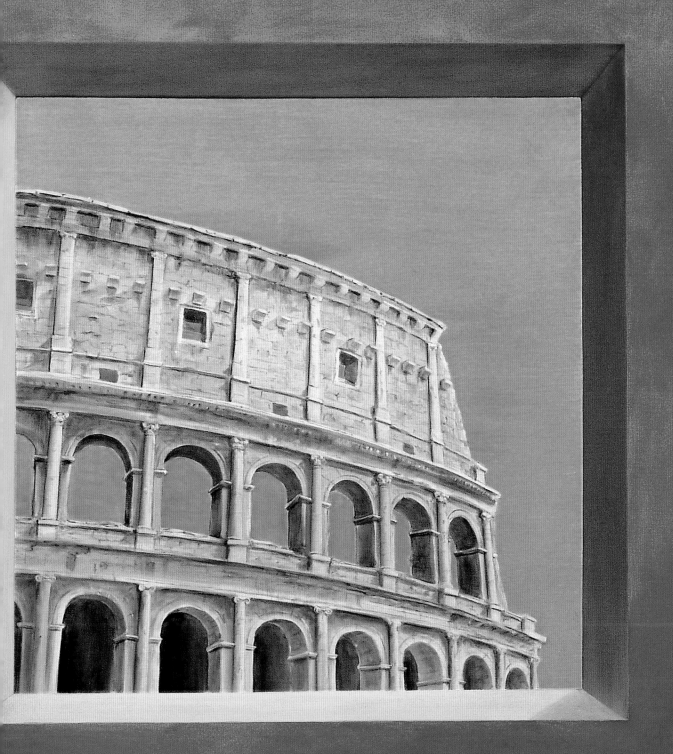

Ursula Evelin Benad, Martin Benad

Atelier Benad

is a leading name in color design in architecture, focusing on trompe l'oeil painting, color psychology, and image décor. Atelier Benad works with private and corporate clients, hotels, and restaurants. Ursula and Martin Benad interpret traditional features in a new way, give a personal touch to current trends, and invent an original palette of colors and images for each project. As authors of eleven books they are outstanding representatives of their field. Ursula Benad heads an academy for color design and mural painting, where talented participants receive in-depth continuing education in trompe l'oeil painting. Artists, painters, interior designers, interior architects, and interested amateurs attend seminars at the Atelier Benad to learn or refine design techniques. You can find the current seminars, all books, and an expansive gallery of images at www.benad.com.

Ursula Evelin Benad

Inspired by her professor's enthusiasm for Italian fresco painting, she studied textile and wall design. Ursula Benad worked first in the textile and fashion industry. As an executive for a large fashion company she traveled worldwide, especially in the Far East and the United States. Several years later she started her own fashion studio in Düsseldorf, where she created samples and collections for international companies. She enjoyed her work very much, but a strong desire to paint never left her. During a three-month stay in Venice she discovered antique painting techniques, trompe l'oeil, and fresco painting even in recently opened stores and restaurants. This was the decisive moment to revive her "old" painting skills, to perfect them and to turn them into a career.

Martin Benad

"My path to color began with philosophy. I wanted to bridge feeling and thinking, experience and understanding," Martin Benad remembers. He studied education and recitation, profiting from his musical training as a choirmaster. For many years he worked as a freelance artist and art educator. His seminars on perception training, color psychology, and holistic thinking led to many requests for interior design. He met his future wife in 1993, which opened a new path to creative collaboration.

Impressions from seminars in the Munich
Atelier Benad.

Ursula and Martin Benad at work in
the Atelier.

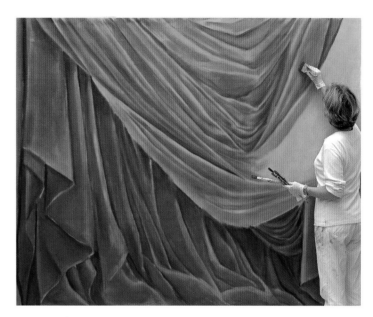

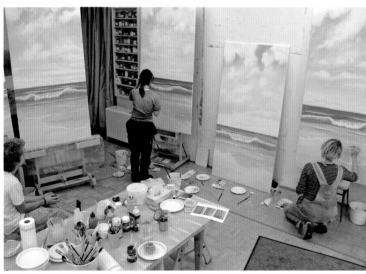

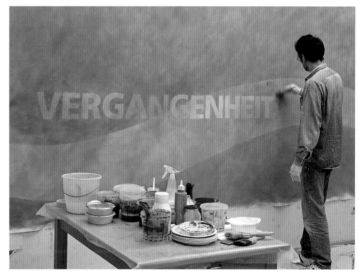